Photographs by a Russian Writer

110 illustrations, 80 in color

PHOTOGRAPHS BY A RUSSIAN WRITER

An undiscovered portrait of

Edited and Introduced by
Richard Davies
With a Foreword by
Olga Andreyev Carlisle

Thames and Hudson

LEONID ANDREYEV

Pre-Revolutionary Russia

First published in the United States in 1989 by
Thames and Hudson Inc., 500 Fifth Avenue,
New York, New York 10110

Library of Congress Catalog Card Number 88-50718

Printed and bound in Hong Kong

CONTENTS

THIS BOOK *could not have been published without the support and co-operation of the Andreyev family, who have generously donated their collections of Leonid Andreyev's papers and photographs to the University of Leeds and have made it possible, for the first time in some fifty years, to gather together the various parts of the Andreyev archive in the West, from as far afield as Argentina and California, as well as from France and Switzerland.*

I therefore wish to take this opportunity to thank for their trust, friendship, kindness and hospitality Leonid Andreyev's grandchildren, Olga Carlisle, Alexander and Génia, and their families, including Nathalie, André and Iégor Reznikoff.

My frequent and much envied research trips to France on the Andreyev trail have been supported by the Sir Ernest Cassell Educational Trust, the British Academy and the University of Leeds, for whose assistance I am most grateful.

In the course of my research I was greatly privileged to meet Leonid Andreyev's two sons, Vadim and Valentin, his daughter, Vera, his step-daughter, Nina, and his two daughters-in-law, Olga and Maria, all of whom have since died. This book is dedicated to their memory.

ВЕЧНАЯ ИМ ПАМЯТЬ !

Richard Davies

Foreword

LEONID ANDREYEV, PHOTOGRAPHER

by Olga Andreyev Carlisle

When I was growing up in the thirties in France my grandfather, the Russian writer Leonid Andreyev who had died in exile in Finland in 1919, was all but forgotten. My father Vadim, his eldest son, was one of the custodians of his father's literary and artistic heritage. We lived in a small modern apartment near Paris, surrounded by handsome oversized objects that had belonged to my grandfather. The bronze inkstand, the tall Remington typewriter, the German camera, the huge unframed charcoal studies looked as if they had come from another, grander world. For in fact they had, they were what was left from Leonid Andreyev's mansion on the Gulf of Finland. Photographs were part of that legacy.

Just before the Revolution, Leonid Andreyev had been one of Russia's most successful writers and the first expressionistic playwright in her history. In the huge wooden house designed by a disciple of the elder Saarinen which he had built on the coast of Finland 40 miles west of St Petersburg, Andreyev led for some ten years, until his death during the Civil War, a fairly isolated existence devoted to the pursuit of art. As he was leaving St Petersburg in 1908 he wrote to his friend Maxim Gorky that, settled in the country, he expected '. . . once and for all to come face to face with nature, with the sea, the sky, the snow, face to face with pure human thought'. But in Leonid Andreyev's life, despite the emphasis on literary work and meditation on what were known then as 'the accursed questions' – the problem of good and evil and the revolution which he considered inevitable – there was time left for children and guests and for sailing, painting, and for photography.

The political disasters Leonid Andreyev had anticipated in his works – World War I, the Revolution, the Civil War – obliterated his literary fame almost overnight. All his life he had been a committed liberal and he found himself in violent opposition to the Bolsheviks when they took power in 1917. He died before he was able to fulfill his last wish, to travel to America to alert the world to the realities of Bolshevik terror. Only in the Khrushchev years was he reinstated in the Soviet Union as an important writer whose existential insights belong to our time. For he was ahead of his own. His younger contemporary, the Symbolist poet Andrei Belyi, took his measure in 1922 as he remembered him:

> He wished to be *enormous* – not for his own sake: he wished to reflect in his transitory tread as a writer – the march of the Century; his gait as he walked through the history of twentieth-century literature sometimes seemed to be a *theatrical* gait. Kornei Chukovsky saw him as a disinterested actor; he was a Don Quixote in the *most beautiful sense*; the greatness of what he created lies in his brilliant striving after the great; the life of his books is an epic. Behind his mask lived the 'I' of the whole world, which he failed to realize.

Today in the Soviet Union each new printing of Andreyev's work is sold out at once. His conviction that Russian and indeed human sensibility must be recreated from within if we are to survive on this planet reflect the spirit of *perestroika* that appears at last to be awakening in Russia. As for his photographs they capture the essence of what the poet Aleksandr Blok had called 'the fabulous years', when Russia seemed on the verge of joining the community of European countries and becoming safely Westernized while retaining its Slavic identity.

One of my earliest childhood memories is of looking at my grandfather's colour photographs in three dimensions through a stereoscopic viewer. I must have been three or four years old. I remember my awe. Through what resembled a pair of cumbersome binoculars I was seeing my father's and grandfather's life precisely as it had been, complete with people and dogs, a house and a garden, clouds and fields and a forest. But in reality this lifelike world was no more. Incomprehensible forces – the passage of time, revolution, death – had engulfed it, yet here it was before my eyes, as vivid as my own life, a miracle, the past recovered.

After a while the stereoscopic viewer disappeared from our apartment. However a number of Leonid Andreyev's colour plates remained in my father's study. Four to a box, they were stored in shallow, shiny black cardboard boxes which fitted in turn inside large, carefully crafted and labelled wooden chests. Stacked up on a shelf these were a promise of breathtaking excursions into the life of my family long before I was born.

I was ready to trade my own childhood for my father's whenever he had the inclination to open the wooden chests and the black boxes and one by one hold up the colour plates to the light. The fact that these were double – twin windows onto the scenes of my father's early years – added to their mysteriousness. Indeed *why* were they double? The explanation that this had to do with their stereoscopic properties was bewildering to a child. As my father held them up to the window while I sat in his lap the double dark-hued glass plates, as delicate as twin butterfly wings, looked magical. Today reproduced in colour on the page they have an eerie immediacy.

As a writer, Andreyev had used in turn a variety of literary modes: realism, symbolism, expressionism. But in his photography he appears to have found an effortless personal style, realistic and yet lyrical. He became a photographer on a grand scale in his thirties, after a long apprenticeship as a painter. After his father's death, while still at school, he had helped his mother support his brothers and sisters by drawing and painting portraits. He continued to paint all his life. However, unlike his manuscripts and photographs, his paintings (works on paper which proved cumbersome and fragile) did not for the most part survive exile and war. The few that remain testify to his considerable technical skills and to a robust, thoroughly gothic vision. They lack the serenity and self-assurance of the photographs.

For several years, using the best of German equipment and French supplies, Andreyev explored the latest photographic techniques. He eventually became involved with the cinema: during a visit to Yasnaya Polyana in 1910, he was able to communicate some of his enthusiasm for this new medium to Lev Tolstoy who had agreed to pose for what must have been one of his last photographic portraits.

But it was colour photography that absorbed Andreyev most, a passion which was humorously described by his younger friend, Kornei Chukovsky:

It was as if he himself were a whole factory, working ceaselessly in shifts, preparing all those masses of large and small photographs which were stacked up in his study, contained in special boxes and chests, overflowing on every table, mounted on the window panes. There was no corner in his house which he had not photographed several times over. Some photographs were extremely successful, for instance spring landscapes. It was hard to believe that they were photographs at all, they were suffused with such elegiac musicality, reminding one of Levitan.

Levitan had been a well-known Russian landscape painter – Chukovsky, like most of Andreyev's contemporaries could not conceive of photography as independent of painting.

But in fact Andreyev's pictures are the work of a photographer in full control of his medium and yet constantly experimenting. Relatives, friends, flowers, rocks, the green waters of the Gulf of Finland, the landscapes of Italy all became his subjects, and he recorded them in photographs which look alive and yet very still. Evocative at times of Bergman's films they suggest an orderly Nordic universe threatened by some ominous upheaval.

It was nothing less than the destiny of man, in its wretchedness and its magnificence, irrevocably flawed by his mortality, that haunted Andreyev all his life. Over the years he took a great many self-portraits. These are not solely an expression of narcissism. Through his own brooding face Andreyev seems to have been seeking Man, whose integrity was about to disappear, forever crushed by the catastrophic blows of the advancing twentieth century.

Though he seldom photographed St Petersburg, it had been the city Andreyev chose to live in and near when he returned to Russia after the death of his beloved first wife, Aleksandra, whom he had courted and married in Moscow. Anna Akhmatova's lines about St Petersburg in 1913 in which she laments the death of Russian culture as it had flowered before the First World War recall Andreyev. With obsessive determination he had struggled all his life to uphold humanistic values. However intuitively, he knew what the modern age had in store for man, and he mourned:

> . . . like a man possessed of demonic fever,
> on a dreadful night reflected in mirrors
> refusing to recognize himself –
> while along the fabulous embankment
> oblivious of the world's calendar
> the true twentieth century edges in.

Leonid Andreyev, 1871–1919

Leonid Andreyev's was among the most original and controversial voices to come out of Russia in the early years of this century. His lifetime, 1871–1919, coincided with one of the more violent convulsions Europe has experienced in its long history, and his particular gift lay in expressing the mood of those decades of upheaval and crisis which culminated in the bloodbath of the First World War. He did so in stories and plays which exercised a powerful grip on the imagination of his contemporaries and enjoyed great success in Russia and abroad. He was all but forgotten after his death, like other writers whose views displeased Russia's new masters, but he has benefited more than most from the gradual rediscovery of the rich literary heritage of the 1900s and 1910s which has been going on in the USSR since Stalin's death. Today Soviet editions of Andreyev's works once more sell in hundreds of thousands of copies, and his literary and historical importance is being increasingly recognized.

Like Proust, Kafka, Joyce and the other great writers of his generation, Andreyev witnessed the death agony of the old order and the birth pangs of the new and wrestled with the problems that transition posed. He, too, was confronted by the destruction of the values which had for centuries given shape and meaning to human existence and had to come to terms with a world in flux. Taking the traditional realistic mode of Russian literature as his starting point, he employed a wide range of means to convey anguished philosophical dilemmas and complex psychological states. The results were often startlingly powerful and revealed a brilliant talent, though the impulse to saturate the emotional atmosphere of his works carried with it the danger of a rhetorical self-indulgence.

What was unknown to his contemporaries – and has remained unknown until our own day – was that Andreyev was not only a writer of genius, but a man of unusual talent in another direction: photography. Andreyev had taken stereoscopic black-and-white photographs from the early 1900s, and shortly after moving to his house at Vammelsuu outside St Petersburg in 1908 he also began taking the stereoscopic photographs in colour on which this book is based. The technique he used for most of his colour photographs had been patented by the Lumière brothers in 1907 and was marketed under the name 'Autochromes Lumière'. Evidence derived from the numbered labels on the boxes in which Andreyev bought and stored his Autochrome plates suggests that between 1908 and 1914 he took about four hundred colour photographs. Of these three hundred survived in his family's possession and now form part of the Andreyev archive at Leeds University, while a further twenty are in the collection of Andreyev documents and memorabilia at the museum in his home town of Orel. Although photography was for Andreyev just one of the hobbies he pursued intermittently in bursts of great intensity, his Autochromes and the 1500 or so stereoscopic black-and-white photographs he also took show him to have been a remarkably gifted photographer, with a lyrical sensitivity to physical beauty unexpected in one whose writings concentrate almost exclusively on philosophical and psychological probings and make minimal use of external description.

Leonid Andreyev was born on 9 August 1871 (Old Style) in the town of Orel, which lies in the Central Russian heartlands about 240 miles south of Moscow. His father, Nikolai, an employee of the local government's land-surveying department, was renowned in the Pushkarnaya district of town where the family lived for his feats of physical strength and drinking bouts. His death at the age of forty-two in 1889 left his wife Anastasia with six children to support, and the modest ease the family had enjoyed during Nikolai's lifetime was replaced by a struggle to make ends meet in which Leonid, as the eldest son and new head of the family, had to play a leading part.

As a child he had been extremely happy, taking the lead in the pranks and escapades of the local children, for whom the semi-rural Pushkarnaya district (which has survived almost intact to this day) must have been a glorious playground, with its broad, unpaved streets, easily accessible gardens and nearby river. Andreyev learned to read at an

early age and was soon devouring adventure fiction of all kinds, including the popular novels of Mayne Reid and Fenimore Cooper, which inspired an unsuccessful attempt to run away to America.

When he was eleven Andreyev gained entry to the Orel grammar school and began a chequered academic career from which he was to gain very little. Unsuited by temperament to the rote-learning and regimentation which characterized Russian schools at that time, he showed promise only in areas where room was left for imagination and originality, namely Russian language and literature and drawing. Soon older schoolmates were lending him prohibited books to read, like the iconoclastic works of the nihilist critic and journalist Pisarev and Tolstoy's *What I Believe*, and Andreyev set out along the path of philosophical self-education trodden by so many young Russians before and since.

Even before his father's death, which must have come as an unwelcome confirmation of life's cruelty and arbitrariness, Andreyev was subject to bouts of black depression and crippling self-doubt. He found little joy in the considerable success he had with the girls of Orel and increasingly sought oblivion in vodka.

So by 1890, the date of his earliest surviving diary, Andreyev's inner life was in turmoil. On the one hand he wanted to believe in the power of human reason to penetrate life's mysteries and to provide reliable criteria for living, while on the other he found himself the prey of irrational impulses and passions over which he could exercise little control. In his diary he subjected every twist and turn of his current love affair to the minutest scrutiny, determined above all to *understand* what was going on inside him. Quoting at length from Schopenhauer's *The World as Will and Idea* and Eduard von Hartmann's long-forgotten *Philosophy of the Unconscious*, he reached gloomy conclusions about the purely physiological basis of sexual attraction and the illusoriness of the romantic trappings with which sex was traditionally draped. In what he was himself to recognize many years later as a prophetic outburst Andreyev wrote in his diary on 1 August 1891 of his wish to become famous and

. . . to write something which would bring together and give shape to the vague strivings, the semi-conscious thoughts and feelings, which are the lot of the present generation. . . . I want to show that there is no truth in the world, no happiness based on truth, no freedom, no equality – nor will there ever be. . . . I want to show the untenability of all the fictions mankind has buoyed himself up with hitherto: God, morality, life after death, the immortal soul, universal happiness, etc. . . . I want to be the apostle of self-destruction. I want my book to affect man's reason, his emotions, his nerves, his whole animal nature. I should like my book to make people turn pale with horror as they read it, to affect them like a drug, like a terrifying dream, to drive them mad, to make them curse and hate me but still to read me and . . . to kill themselves. I want to make fun of mankind, to laugh long and heartily at its stupidity, egoism and gullibility.

Commenting on this extraordinary declaration of intent in 1918, when his whole world lay in ruins and he was marooned in Finland, Andreyev mused:

At that time I was still not quite twenty, I had not yet written anything, apart from school essays, and the whole thing could be dismissed as mere bravado on the part of a provincial youth who had read his fill of Hartmann . . . were it not for what followed. How could a mere slip of a lad have been so fully formed as to map out his path so clearly, even if naively? The once terrifying name of Leonid Andreyev was the fulfilment of that childish dream.

Meanwhile, in the autumn of 1891, Andreyev entered St Petersburg University as a student of Law. It was to be six years before he finally graduated. He was desperately poor, drank heavily, made more than one clumsy effort to commit suicide, caused himself and his girlfriends much misery, studied without enthusiasm or application, and took little part in student political and self-educative

activities. Halfway through this dark period Andreyev transferred to Moscow University and was eventually joined in Moscow by his mother and family, a circumstance which introduced a note of stability into his chaotic existence. Soon after he arrived in Moscow Andreyev met and began courting his future first wife, Aleksandra Veligorskaya, then still in her teens.

By comparison with his last years at school in Orel, Andreyev's student years were strikingly deficient in intellectual growth, although his discovery of Nietzsche's *Thus Spake Zarathustra* had a lasting effect on him. He frequently complained in his diary that he had stopped reading and could no longer express himself on paper clearly and eloquently, blaming this decline largely on his debilitating way of life. Nevertheless, soon after arriving in St Petersburg in 1891 he had started to compose and publish short stories. None of them were considered by Andreyev for inclusion in his collected works in the 1910s, and they are undoubtedly weak artistically. But they display certain features, in particular a tendency towards abstraction and allegorism, which went underground in the more traditionally realistic stories Andreyev was to write at the start of his literary career proper, to surface again in his later, most 'Andreyevan' works.

When Andreyev graduated in 1897 he fully intended pursuing the legal career for which he was qualified and indeed practised intermittently as a barrister for some time. But it was the offer of work as a court reporter on the Moscow newspaper *The Courier* which determined the direction of his life for the next five years or so and which might even be said to have at long last *given* his life some direction. Andreyev's reports quickly attracted attention by their vivid psychological portraits of defendants and their concern with the social background to crime. His editor encouraged him to submit original stories for publication. And so it was that on 5 April 1898 Andreyev's story *Bargamot and Garaska* appeared in the Easter issue of *The Courier* and his literary career was launched.

As luck would have it, *The Courier* was being supplied to subscribers of another newspaper, which had been temporarily banned, and among them was Maxim Gorky, who was struck by Andreyev's unconventional handling of the notori-

ously sentimental Easter-story genre. Gorky followed Andreyev's progress and in 1899 helped him place his stories in the popular *Journal for Everyone*. The two soon became firm friends. Gorky's advice, encouragement and support were of crucial importance for Andreyev. Through him Andreyev was introduced to the *Wednesday* circle of anti-establishment writers, at whose meetings new works were read aloud and discussed. Gorky was instrumental in arranging for Andreyev's first collection of stories to be published in 1901. Contact and correspondence with Gorky stimulated Andreyev to reflect on his literary calling, the social responsibility that being a writer in Russia traditionally involved, the political situation in Russia and abroad, a whole range of problems, in other words, for which his youthful preoccupation with his own intellectual and emotional difficulties had left little time.

Andreyev was eventually promoted from court reporter to feuilletonist on *The Courier*. In hundreds of weekday columns and Sunday articles he wrote about everything from the problems of finding a flat in Moscow to the wickedness of the British during the Boer Wars. He propounded views of a generally liberal and democratic complexion, which were shared by most self-respecting intellectuals of the time, and in Andreyev's case led to frequent conflicts with the censors.

Something of the same positive spirit informed the stories Andreyev wrote while working for *The Courier*, if only to the extent that in many of them Andreyev left open the possibility that changed circumstances would remove the causes of the problems he explored. These were essentially problems of the individual and his relations with his fellow human beings, either at an intimate level, or in the context of society as a whole. Andreyev's approach was psychological, and he seemed mainly concerned to show the dangers of the solipsism he himself had fallen victim to at an early age and the individual's need for genuine contact with other people.

Any schematic reduction inevitably fails to do justice to the suggestive richness of individual works, and even in stories where a shift from negative premises to positive conclusions is shown explicitly Andreyev's deep-rooted scepticism gives rise to considerable ambiguity. Is it only the circumstances of this particular life which push people into

solipsism, or is Life itself at fault? There certainly seems little way out for the heroes of *The Lie* (1900) and *Laughter* (1901), faced as they are by the impossibility of achieving ultimate union with another person, here the girls they love. And it takes some stretching of the imagination to accept Andreyev's own positive gloss on *The Wall* (1901), in which repulsive lepers perish at the foot of a wall they can never scale.

The stories Andreyev published in *The Courier* and elsewhere between 1898 and 1901 attracted little attention outside the circle of Gorky and the *Wednesday* group. But his first book of stories, published in September 1901, was greeted by the revered Populist critic Mikhailovsky in a long and enthusiastic review, and Andreyev suddenly found himself a national celebrity. Demand for the book was so great that it had to be reprinted several times and sold tens of thousands of copies between 1901 and 1905. Critics vied with one another in praising this new recruit to the ranks of Russian literature. However, the greatest boost to Andreyev's burgeoning reputation was given by the extraordinary attack Countess Tolstoy mounted on him in early 1903 for the alleged pornography of *The Abyss* and *In the Fog*. Readers' letters poured in from all over Russia pledging support for Andreyev in his stand against hypocrisy and his courageous presentation of young people's sexual problems. For the next ten years at least Andreyev was to be one of Russia's most controversial literary figures, both admired and detested by vast numbers of readers, hot copy for the serious and the scurrilous press alike, suspected of subversion and spied on by the secret police.

In February 1902 Andreyev finally married Aleksandra Veligorskaya after a long and often stormy courtship, and at Christmas 1902 their first son, Vadim, was born. Andreyev's life became much more settled under Aleksandra's influence, and with her he came near to achieving a happiness and stability which he was disposed to doubt could exist at all, let alone endure.

The works Andreyev wrote between 1903 and 1906 reflected his new personal and professional fulfilment in their greater artistic mastery, philosophical range and psychological penetration, without losing anything of the urgency and ambiguity of earlier stories. Indeed as Russia's social and political crisis gathered momentum the mood of Andreyev's works became ever more apocalyptic and their tone increasingly strident. Andreyev spent much of 1903 working on *The Life of Father Vasily Fiveisky* (1904), the longest and most thoroughly wrought story of this period and his first undisputed masterpiece. The atmosphere of impending catastrophe with which this story is imbued also informs the brilliant miniature *The Thief* (1905) and reached a climax in *The Red Laugh* (1905), inspired by the disastrous Russo-Japanese War of 1904, and Andreyev's first essay in the jagged, stark, almost hysterical mode which many critics have seen as an anticipation of Expressionism. In the context of such manifestly explosive works even the apparently calm *Phantoms* (1904) emerges as a demonstration of stylistic and psychological tightrope-walking, full of tension and potential danger.

In February 1905 Andreyev was arrested and briefly imprisoned for allowing his apartment to be used for a meeting of the central committee of the proscribed Social Democratic Party. The experience of comradeship among his fellow-prisoners in the Taganka gaol fired Andreyev with revolutionary enthusiasm, and hope for a brighter future briefly overcame his deep-rooted doubts about mankind's capacity for collective self-improvement.

Nearly all the works Andreyev wrote and published during 1905 and 1906 had overtly revolutionary themes and were seen both by the reading public and the Tsarist authorities as giving encouragement to the revolutionary cause. Yet none of them escapes the ambiguity which is so characteristic of Andreyev's vision. The central figure of *The Governor-General*, written during the summer of 1905, attracts the reader's sympathy by accepting the justice of his assassination by revolutionary workers in retaliation for the massacre of their starving workmates, wives and children during a demonstration. Shortly before the 1905 Revolution itself Andreyev finished writing his highly equivocal evocation of the French Revolution, *Thus It Was*, and his first completed play, *To the Stars*, in which a detached, cosmic view of human endeavour is not unfavourably contrasted with various brands of revolutionary activity.

Andreyev's revolutionary credentials were nevertheless sufficient to earn him a place on the death list of the Black Hundreds, Russia's thugs of the right, and under this threat he and his family fled to Berlin

at the end of November 1905. Later that winter they travelled to Munich and Switzerland, before returning to the relative safety of the semi-autonomous Grand Duchy of Finland in May 1906. In Munich Andreyev wrote his second play, *Savva*, in which the young anarchist hero who tries to force enlightenment on the masses by blowing up a miraculous icon is killed by the very crowd he wishes to save.

Despite the constant critical examination to which Andreyev subjected revolutionary topics in his works, he associated while abroad with Russian revolutionary exiles and European workers' groups, and shortly after his return to Finland was caught up in the events surrounding the prorogation of Russia's first parliament, the Duma, and the mutiny of the Russian fleet at Helsingfors, addressing a mass rally there in July 1906 and once more being forced to flee, this time to Sweden and Norway. In August 1906 Andreyev made his way to Berlin and was joined there by Aleksandra who was pregnant with their second child.

While waiting for the birth Andreyev wrote the first of his major works based on a Biblical subject, *Lazarus*, and his most innovatory play, *The Life of Man*, which was to earn him a lasting place in the history of Russian theatre through productions at the Moscow Art Theatre and Komissarzhevskaya's theatre in St Petersburg. Both *To the Stars* and *Savva* were performed in Vienna shortly after the birth of the Andreyevs' second son, Daniil, in November 1906, and Andreyev's affairs seemed to be flourishing when suddenly Aleksandra contracted a postnatal infection and died in December 1906.

Andreyev was shattered. Accompanied by his mother and his three-year-old son, Vadim, he took up Gorky's invitation to join him on Capri, while Daniil was sent back to Russia with Aleksandra's mother to be brought up by her and her elder daughter. He was never to join his father's household except for short visits.

Gradually Andreyev recovered sufficiently to resume work and while on Capri wrote his tormented and paradoxical *Judas Iscariot*. The blow of Aleksandra's death left a permanent mark on him, however, and the coincidence of his personal tragedy with the suppression of the revolution in Russia confirmed his worst fears of life's malevolence. As if that were not enough, his friendship with Gorky,

which had been one of the pillars of his universe, began to show signs of strain. Theirs had always been a marriage of temperamental opposites, but it took the upheavals of the revolutionary years fully to reveal their profound ideological incompatibility.

In the spring of 1907 Andreyev left Capri and rented a villa in one of the many resort settlements that were springing up along the Gulf of Finland just outside St Petersburg. He purchased a plot of land and commissioned a young architect fresh from Eliel Saarinen's studio in Helsingfors, Andrei Ol, to build him the house of his dreams, as described so vividly in *The Life of Man*. For the winter he took an apartment in a modern part of St Petersburg and there resumed his literary life, entertaining, giving readings, establishing new contacts. These included the young Symbolist poet, Aleksandr Blok, who was enthusiastic about *The Life of Man* in Meyerhold's brilliant production at Komissarzhevskaya's theatre. It was Blok who read Andreyev's *Darkness* at the first Wednesday meeting Andreyev organized in St Petersburg in September 1907.

The contrast with the Moscow Wednesday meetings of a mere two years previously could hardly have been greater. Andreyev's break with his whole Moscow past and its unbearably painful associations with Aleksandra was as complete as he could make it. He would never again live in Moscow, and the rest of his life revolved around his extraordinary house at Vammelsuu in the rather alien, or at least distinctly un-Russian surroundings of the Karelian Isthmus.

Darkness was based on an incident described to Andreyev on Capri by the celebrated terrorist (and subsequently engineer of the Palestinian water system) Rutenberg, and Andreyev's reworking of the story of a revolutionary who takes refuge from the police in a brothel deeply offended Gorky by its wilful departure from the original and particularly by the transformation of the central figure into a bloodless fanatic who ends up discarding his revolutionary ideals and plunging into the darkness of debauchery. Although their correspondence limped on into 1908 before breaking off for several years, with Andreyev reassuring Gorky that he had not sold out to the forces of reaction, the two had drifted too far apart artistically and politically for anything more than polite relations to be maintained.

Almost as soon as he completed *Darkness* in September 1907 Andreyev began writing *King Hunger*, the most Expressionistic of his plays. In *King Hunger* Andreyev appeared to many to be reneging on the revolution with which he had previously been so publicly identified. Try as he might to defend himself from this accusation by claiming that he had been depicting the mindless violence of riots and rebellion and not the revolution proper, such distinctions were beyond the comprehension of most of his critics.

Andreyev redeemed himself, however, with *The Seven That Were Hanged*, written in early 1908 in response to the wave of executions of revolutionaries that swept Russia as the Tsarist authorities reasserted their control after the brief spell of concessions and reforms forced upon them by the 1905 Revolution. The main thrust of *The Seven That Were Hanged* is directed against the very concept of capital punishment, and Andreyev devotes hardly any space to the cause for which his five chief protagonists go to their deaths. Nevertheless, the narrator's sympathy for the condemned terrorists is manifestly of a different order from his pity for the two common criminals also portrayed, and it contrasts tellingly with his scorn for the terrorists' proposed victim. *The Seven That Were Hanged* was hailed internationally as a condemnation of Tsarist oppression. It sold hundreds of thousands of copies all over the world and remains to this day the single work by which Andreyev is best known.

The burst of creativity which followed Andreyev's return to Russia from Capri was accompanied by unabated inner turmoil in the wake of Aleksandra's death. *The Curse of the Beast*, written in August 1907, was a more or less deliberate exercise in stylistic and emotional self-indulgence which helped Andreyev to come to terms with his loss. But he badly need to find a replacement for Aleksandra and stumbled from one potential wife to another before meeting Anna Denisevich, who had been introduced to him by the young critic, Kornei Chukovsky, and whom he married in April 1908.

Shortly afterwards the house at Vammelsuu was completed, and Andreyev took up residence there with Anna, her daughter by a previous marriage, Nina, his son, Vadim, and his mother. A new chapter in Andreyev's life began.

Established at Vammelsuu, Andreyev settled into a way of life which was to run smoothly, on the surface at least, until the outbreak of the First World War six years later. Anna gave birth to a son, Savva, in March 1909, and two more children, Vera and Valentin, followed in 1910 and 1912. Andreyev's brothers, Pavel and Andrei, and his sister, Rimma, were frequent visitors, bringing with them their own young families. The house was always full of guests, and hospitality was writ large in the traditional Russian manner. Several summers were spent yachting among the skerries in the Gulf of Finland. There were trips abroad, to Hamburg and Amsterdam in 1909, to Marseilles, Corsica and Florence in 1910, to Italy twice again in 1913 and 1914.

Andreyev now had the leisure to pursue his various artistic interests. He had been an accomplished draughtsman since his schooldays and had even earned extra money as a student by producing pencil and pastel portraits. To decorate his vast study on the first floor of the Vammelsuu house he drew some greatly enlarged copies of etchings by Goya, who was one of his favourite artists. He also made his first attempts at oil painting and achieved impressive results, particularly in a group of canvasses reminiscent of Edvard Munch. His photographs were clearly another product of this sensitivity to visual images.

At night, when the guests and reporters had left, the telephone had stopped ringing, and the household had gone to bed, Andreyev would turn to his latest piece of work, writing or more often typing until the early morning, fortified by endless glasses of pitch-black tea, toffees and cigarettes. The break with his past signalled by the move to Vammelsuu was also reflected in Andreyev's creative development from late 1908 onwards. With a handful of exceptions his literary output now consisted almost entirely of plays. Substantial narrative works were few and far between: the polemical *chef d'oeuvre, My Notes*, written in the summer of 1908, the irredeemably disastrous novel *Sashka Zhegulev*, completed in the autumn of 1911, the haunting *He* a year later, and Andreyev's last completed major fiction, *The Burden of War*, published in 1916. Andreyev continued writing short stories on and off throughout this second part of his literary career, but although some of them certainly deserve more attention than they are usually paid, they were for the most part

occasional, would-be humorous pieces executed in a rather arch, laboured manner with little of the structural or stylistic originality which distinguished his earlier stories.

It was chiefly on his plays, then, that Andreyev's reputation rested during the Vammelsuu period. *Days of Our Life*, first staged in November 1908, drew on Andreyev's student experiences to produce an eminently theatrical work which immediately became a firm favourite with audiences all over Russia and has retained a place in the repertoire ever since. Its straightforward realism and strong characterization contrasted with the extreme experiments of *The Life of Man* and *King Hunger*, while its uncontroversial, even melodramatic, subject-matter represented a departure from the revolutionary themes of *To The Stars* and *Savva*. Yet in the *The Black Maskers*, written immediately after *Days of Our Life* in 1908, and *Anathema*, the second of Andreyev's plays to be performed by the Moscow Art Theatre, in 1909, he was again making full use of innovatory techniques and, in *Anathema*, exploring among other things the social issues of poverty and suffering. In later plays Andreyev continued to experiment and consolidate by turn, seeing nothing contradictory in stylistic variety and always allowing his subject-matter to find its own formal embodiment. Thus the semi-symbolistic drama of contemporary sexual mores, *Anfisa* (1909), was followed by the realistic *Gaudeamus* (1910), a sequel to *Days of Our Life*, and *The Ocean* (1911), in which Andreyev employed a powerful lyricism of a sub-Nietzschean variety in order to debunk the current cult of the Superman.

In 1912–1913 Andreyev published two *Letters on the Theatre*, in which he argued for a division between the theatre, which was to depict inner drama, and the cinema, which was to take over the presentation of external action. It is debatable how far or how successfully Andreyev put the precepts of the theatre of pansyche, as he called it, into practice in his own plays. Perhaps the best example of an attempt to achieve the goal of inwardness was *Thought*, the adaptation of his 1902 story which he made in 1913 and which the Moscow Art Theatre performed in 1914. Given an outstanding actor in the central role of Dr Kerzhentsev *Thought* can be brilliantly effective on stage.

All the plays Andreyev wrote between 1908 and 1914 attracted lively public attention. Copies of the published texts sometimes sold out within days of their appearance in the bookshops. The leading metropolitan and provincial theatres vied with one another to produce his latest works. Several productions were banned by the censors on grounds of alleged blasphemy or impropriety, and this inevitably generated even more avid interest. The issues raised by some plays were hotly debated in the press and at public lectures and meetings. Professional critics cooled towards Andreyev over this period, but his popularity with large sections of the public was undiminished, so much so that two separate editions of his collected works were issued between 1911 and 1913.

Andreyev remained at the forefront of Russia's literary and particularly theatrical life during the First World War, although much of the momentum went out of his creative work when he returned to active journalism on the outbreak of hostilities. He also suffered long spells of illness and underwent treatment for neuralgia. Of the plays he wrote, only *He Who Gets Slapped* (1915) made a significant impact at the time, with celebrated productions at the Moscow Dramatic Theatre and the Alexander Theatre in Petrograd (as St Petersburg had by then been renamed).

Andreyev had reacted to the declaration of war on Germany and Austria-Hungary with a patriotic fervour which must have seemed to contradict all he had stood for when he wrote *The Red Laugh* and *The Seven That Were Hanged*. In a stream of articles written in late 1914 and early 1915 he called for support for the war effort and attacked the Germans as a threat to the whole civilized world. He also took a prominent part in the activities of various war charities. Part of Andreyev's enthusiasm can be explained by the sense of release and uplift experienced by so many European artists and intellectuals after the years of tension and impending doom of which they were such sensitive barometers. But Andreyev was also guided by his conviction that only the defeat of German imperialism would clear the way for the overthrow of Russian autocracy from within Russia, whereas a German victory would destroy any such chance. In other words he believed he was choosing the lesser of two evils in backing the war and insisted that his abhorrence of war and bloodshed was undiminished.

Although Andreyev was far from alone among famous literary figures in adopting a pro-war stance, hatred of Tsarism was so deeply engrained in the outlook of the Russian intelligentsia that there was a significant lobby which actively wished to see Russia defeated in the war. This view became a particular target of Andreyev's polemical articles in *The Russian Will*, a Petrograd daily in which he played a leading role from its inception in December 1916 to its enforced demise in October 1917. Andreyev greeted the February Revolution in 1917 as the fulfilment of all his hopes for the replacement of Tsarist autocracy by a democratic republic, and he proclaimed the dawn of a new era of liberty in Russia. He was consequently dismayed and alarmed by the turn events took during the spring and summer of 1917, as the Bolsheviks exploited every opportunity to undermine the Provisional Government led by Kerensky, and he did his utmost in a series of impassioned and prophetic articles to stem the tide of anarchy and chaos which threatened to engulf Russia. Two of Andreyev's last articles in *The Russian Will* contained a bitter personal attack on Lenin and an appeal to the Allies to rescue Russia from the twin dangers of the Germans outside Petrograd and the Bolsheviks within.

It was too late, and when the Bolsheviks toppled Kerensky and seized power on 26 October 1917 Andreyev left Petrograd for Vammelsuu. Shortly afterwards Finland declared its independence and Andreyev found himself cut off from Russia by the new Finnish frontier. There followed months of physical privation and mental anguish as Andreyev and his young family battled for survival against the cold and hunger of winter and the vagaries of the Finnish Civil War being waged around them. News from Russia was hard to come by and unreliable, the fate of relatives and friends was uncertain. Andreyev's health gave way under so much strain, and he was never fully to recover from the heart ailment and nervous complaints which afflicted him.

Andreyev's frustration at his inactivity and isolation from events knew no bounds, but it was not until early 1919 that he finally managed to make himself heard again. In his article *S.O.S.*, which was published all over Europe and in the USA, Andreyev once more called on the Allies to come to Russia's aid, reiterating some of the arguments from his last article in *The Russian Will*. Encouraged by the response to *S.O.S.*, Andreyev offered his services as a propagandist to the fledgling North-West Government which had been set up in Helsingfors under General Yudenich to coordinate anti-Bolshevik forces in Russia's former Baltic provinces. Suspicion of Andreyev as a long-standing critic of Tsarism and supporter of the February Revolution, as well as a failure to appreciate the value of propaganda, led to Andreyev's offer being rejected. Undeterred, Andreyev set about organizing a lecture tour of the USA to alert the American public to the danger of Bolshevism. But like his childhood attempt to run away to America under the influence of Mayne Reid and Fenimore Cooper this far more serious plan was not destined to be carried out, and shortly before he was due to leave Finland Andreyev suffered a brain haemorrhage and died on 12 September 1919 at the age of forty-eight.

Interest in writers who achieve during their lifetime the degree of fame Andreyev enjoyed nearly always slumps after their death, as if their readers need to recover from over-exposure to their works and gain some perspective on them. In the normal course of events the test of time is applied, and the writer's true stature gradually emerges, with some works perhaps coming to be seen as classics, while others turn out to be of no more than historical importance. The course of events in Russia was so far from normal and the break with the pre-Revolutionary past so abrupt, that Andreyev's works had no opportunity to stand the test of time as such. In the decade after his death some of his early stories were republished, memoirs and editions of letters began to appear, promising biographical and critical studies were undertaken. But the prevailing ideological climate was hardly favourable to a dispassionate reassessment of someone who had after all persistently and vociferously opposed Russia's new rulers and welcomed Allied intervention, and for the following quarter of a century Andreyev was virtually ignored in the USSR.

Only with the onset of the Thaw in the mid-1950s was Andreyev taken out of cold storage and given a new lease of life. Editions of Andreyev's selected stories now follow one another in quick succession and sometimes sell out as fast as they used to in the 1900s and 1910s; successful productions of plays have taken place; hundreds of popular and scholarly

articles and several monographs have been published; impressively annotated editions of letters have been prepared from rich Soviet archival holdings; many commemorative meetings and academic conferences have been held. Thanks to the efforts of a devoted band of enthusiasts, including many academics and several members of the Andreyev family, Andreyev has been given a place both in Russian literary history and in the current literary experience of Soviet readers.

Andreyev died too soon to contribute significantly to the rich culture which flourished in the Russian diaspora between the wars. His unfinished novel *Satan's Diary* and two plays, *Samson in Chains* and *The Waltz of the Dogs*, were published posthumously but made little impression. For Russian emigrés, as in different ways for Russians in the USSR, life had been so violently transformed by the upheavals of 1917, and the problems they now faced were so immediate and basic, that Andreyev's preoccupations seemed irrelevant and outmoded. Nor did his works offer them the consolation of nostalgia for the Russia they had lost, as Andreyev's had always been a muse of crisis and tension with little time for life's simple joys.

Perhaps Andreyev's particular sensitivity to the atmosphere of a society riven by social and political strife and approaching collapse helps explain why, at a time of neglect by his compatriots, his works enjoyed great popularity in the countries of Central Europe and the Balkans, as well as in Italy, Spain and Latin America.

Some seventy of Andreyev's works exist in English translations published in Britain and the United States from around 1908 onwards. Several collections of stories and plays were issued during the First World War and some of them ran to as many as three or four editions over the following decade or so. Individual works appeared in a wide variety of journals and anthologies throughout the interwar years, as well as in separate book editions.

Many translators were active in promoting Andreyev's works in the English-speaking world. Pride of place for sheer energy and determination must belong to the Russian-American journalist Herman Bernstein, who first visited Andreyev at Vammelsuu in 1908 and whose translation of *The Seven That Were Hanged* quickly became a classic in its own right. Thanks to Bernstein much information about Andreyev and several translations were published in *The New York Times* in the 1910s, bringing Andreyev to the attention of a wide readership, and it was to Bernstein that Andreyev turned just before his death for help in organizing his proposed tour of the USA.

Andreyev's most successful play on the American stage, *He Who Gets Slapped*, was translated not by Bernstein but by Gregory Zilboorg, in whose version it saw over 300 performances by the Theater Guild at New York's Garrick and Fulton Theatre in 1922. That long run laid the foundations for the play's distinguished stage life in America, where it is to this day perhaps the single work by which Andreyev is best remembered. *He Who Gets Slapped* was also made into a fine silent movie by Victor Seastrom in 1924, with Lon Chaney and Norma Shearer in the leading roles; and in 1956 Robert Ward based an opera on the play.

Foreign interest in Andreyev varied widely from country to country and from period to period. What momentum Andreyev's works did develop tended to be interrupted by extraneous factors. Besides, even Dostoevsky and Chekhov were only beginning to make a major impact in the West during the 1920s and 1930s, and there is presumably a limit to the amount of foreign material a culture can absorb at any one time. So the patchiness of Andreyev's reputation should not be seen as a conclusive rejection of him by foreign readers. They have yet to be given a proper chance to make up their minds.

The totally unexpected discovery of the photographs reproduced here must also have its effect in focussing attention on him. He becomes a figure in context, the only major pre-Revolutionary cultural figure to be so intimately revealed. To present-day Russians as well as to us in the West these images are moving not only for their intrinsic quality but also for their poignancy, a poignancy which Andreyev, for all his power and passion as a writer, could express only in this way.

I Image and self

To anyone familiar with Andreyev's writing, the photographs in this book will come as a profound shock. Somehow, we feel, his tormented inner life must have been a reflection of equally troubled outward circumstances. Yet for the most part this was simply not the case. What we see in many of his photographs is a way of life fairly typical for prosperous and leisured people at the time; and despite his restless spirit, Andreyev's evocation of the countryside, which he so clearly loved, is full of serenity and charm. The lesson is clear. Andreyev's nature was not a simple one. It had many levels, and these photographs can reveal to us an unexpected new dimension.

Not all of them are sunny. Sometimes the darker side of Andreyev's imagination does come through. In this first section are images which could occur only to a man of Andreyev's peculiar vision, suggestions of that horror and fear so pervasive in his literary work. To understand them fully we need to see Andreyev from both the inside and the outside. Here, in a passage from a letter to Aleksandra written a few days before their marriage in 1902, Andreyev reveals his own view of his inner world. It is followed by an account of Andreyev in his heyday as he appeared to one of his most perceptive friends.

My life was a wilderness and a tavern, and I was lonely, and I was no friend to myself. There were days, bright and empty, like someone else's birthday, and there were nights, dark and terrifying, and at night I thought about life and death, and I was afraid of life and death and did not know which I wanted more – life or death. The world was endlessly huge, and I was alone – a sick, yearning heart, a clouded mind and a malevolent, impotent will.

And phantoms came to me. A black serpent crawled in and out soundlessly, shook its head inside the white walls and taunted me with its stinging tongue; ridiculous, monstrously ugly faces, terrifying and funny, bent over my pillow, laughed noiselessly at something and reached towards me with their lips, thick and blood-red. And there were no people; they were asleep and did not come to me, and the dark night stood motionless over me.

And I shuddered at the horror of life, alone in the night and among people, and no friend to myself. My life was sad and being alive terrified me.

I always loved the sun, but its light was terrifying for the lonely, like the light of a torch over an abyss. The brighter the torch, the deeper the chasm, and my loneliness was horrible in the bright light of the sun. And it gave me no joy – my beloved and merciless sun.

My death was already near. And I know, I know with my whole body, which trembles at the recollection, that the hand now writing this would be in the grave – but for the appearance of your love, for which I had been waiting for so long, which I had so often dreamed of and had wept for so bitterly in my perpetual loneliness.

My tongue is weak and poor. I know many words which are used to speak of grief, fear and loneliness, but I have still to learn the language of great love and great happiness. All the words in the world are worthless and pathetic in the face of this immensely great, joyful and human thing stirred in my heart by your pure love, by your voice full of pity and love from that other, bright world, which my soul had constantly striven to enter. . . .

Life is ahead, and life is a frightening and incomprehensible thing. It may be that its

implacable and terrible force will crush us and our happiness – but even as I die I shall say one thing: I saw happiness, I saw humanity, I lived! . . .

Less than five years were to pass before Andreyev's happiness was indeed crushed by Aleksandra's death, and although he regained an outward equilibrium and started a new life and a new family in a new place, his inner turmoil persisted. The contrast between Andreyev's flourishing external life and his ineradicable despair at the tragedy of existence is perhaps best conveyed in the memoir composed shortly after Andreyev's death in 1919 by his friend and frequent visitor, the critic Kornei Chukovsky, who in the mid-1950s was among the first to break the silence around Andreyev's name in the Soviet Union by reissuing his memoir several times and supporting the republication of Andreyev's works. Chukovsky's memoir is particularly interesting because it shows Andreyev in the midst of his enthusiasm for colour photography and also makes clear the way in which he threw himself into playing different roles – an aspect of his character which comes through strongly in many of the photographs.

He loved the enormous.

On the enormous desk in his enormous study there stood an enormous ink-well. But there was no ink in it. It was pointless trying to dip the enormous pen into it. The ink had dried up.

'I haven't been writing for three months now,' Andreyev said. 'The only thing I read is *The Helmsman* . . .'

The Helmsman was a sailing magazine. There at the end of the table lay the latest issue with a drawing of a yacht on the cover.

Andreyev walked about his enormous study talking seafarer's shop: topsails, anchors, sails. Today he is a sailor, a sea-wolf. He even walks like a sailor. Instead of a cigarette he smokes a pipe. He has shaved off his moustache, his shirt is open at the neck like a sailor's. His face is tanned. A pair of sea binoculars is hanging from a nail.

You try talking about something else. He only listens out of politeness.

'Tomorrow morning we'll go out in *Savva*, but for now . . .'

Savva is his motorboat. He talks about accidents, submerged rocks and shoals.

Night. Four o'clock. You sit listening on the couch, while he walks about delivering monologues.

He always delivers monologues. His speech is rhythmical and flowing.

Every so often he stops, pours himself a glass of strong, cold, black tea, knocks it back in one go, like a glass of vodka, feverishly swallows a caramel and carries on talking, talking . . . He talks about God, about death, about all sailors believing in God and how, surrounded by chasms, they feel the closeness of death throughout their lives; contemplating the stars every night, they become poets and sages. If they could express what they feel while on watch somewhere in the Indian Ocean beneath the enormous stars, they would eclipse Shakespeare and Kant . . .

But at last he grows tired. His monologue is interrupted by long pauses. His step becomes listless. It is half past five. He drinks another couple of glasses, picks up a candle and goes to bed:

'Tomorrow we'll go out in *Savva*.'

A bed has been made up for you nearby, in the tower. You lie down but cannot fall asleep. You think to yourself: 'How tired he must be! After all tonight he covered *at least twelve miles* walking about his study, and if what he said tonight had been written down, it would make a sizeable book. What a crazy waste of energy!'

In the morning we put out to sea in the tender *Khamoidol*. Where on earth did Andreyev get that Norwegian fisherman's leather hat from? . . . And his high waterproof boots, just like the ones pirates wear in films? Give him a harpoon and he would make a wonderful Jack London whaler.

We reach the yacht. There is the gardener, Stepanych, made up as the boatswain. We sail about the Gulf of Finland until late in the evening, and I cannot stop admiring this brilliant actor who for twenty-four hours has been playing such a new and difficult role, playing to himself, without an audience. How he fills his pipe, how he spits, how he looks at the toy compass! He sees himself as the captain of an ocean liner. Standing with his powerful legs set wide apart, he looks intently and silently into the distance; he gives a sharp command. Not a word to the passengers: since when does the captain of an ocean liner talk to his passengers! . . .

●

When you came to visit him again a few months later, you found he had become a painter.

His hair was long and flowing, his beard short like an aesthete's. He was wearing a black velvet jacket. His study had been transformed into a studio. He was as prolific as Rubens, not putting his brushes down all day. You go from room to room, he shows you his golden, greenish-yellow pictures. Here is a scene from *The Life of Man*. Here is a portrait of Ivan Belousov. Here is a large Byzantine icon, naively sacrilegious, depicting Judas Iscariot and Christ. They look like twins and share a halo over their heads.

All night long he walks about his enormous study talking about Velasquez, Dürer, Vrubel. You sit on the couch and listen. Suddenly he screws up one eye, steps back, surveys you like an artist, then calls his wife and says:

'Anya, just look at that chiaroscuro!'

You try talking about something else, but he only listens out of politeness. Tomorrow is the opening of an exhibition at the Academy of Arts, yesterday Repin came to visit him, the day after tomorrow he is going to see Gallen-Kallela . . . You want to ask: 'What about your yacht?' But the family signal to you not to ask. Once he is caught up in something, Andreyev can only talk about that one thing, all his previous enthusiasms become hateful to him. He does not like to be reminded of them.

When he is playing an artist, he forgets his previous role as a sailor; in general he never returns to his previous roles, however brilliantly he had played them.

And then there was colour photography. It was as if he himself was a whole factory, working

ceaselessly in shifts, preparing all those masses of large and small photographs which were stacked up in his study, contained in special boxes and chests, overflowing on every table, mounted on the window panes. There was no corner in his house which he had not photographed several times over. Some photographs were extremely successful, for instance spring landscapes. It was hard to believe that they were photographs at all, they were suffused with such elegiac musicality, reminding one of Levitan.

In the course of a month he made thousands of photographs, as if fulfilling some colossal order, and when you visited him he made you look through all those thousands, ingenuously convinced that for you, too, they were a source of bliss. He could not imagine that there might be people who would find his plates uninteresting. It was touching to hear him trying to persuade everyone to buy a camera for colour photography.

At night, pacing up and down his enormous study, he would deliver monologues on the great Lumière who had invented colour photography, on sulphuric acid and potash . . . You sat on the couch and listened.

Every one of his enthusiasms turned into a temporary mania, which absorbed him totally.

A whole period of his life was coloured by his love for gramophones – not just love, but mad passion. It was as if he had fallen ill with gramophones, and it took several months for him to be cured of this illness.

●

This lack of moderation was his chief characteristic. He was drawn to everything colossal.

The fireplace in his study was the size of a gateway, while the study itself was like a square. His house in Vammelsuu towered over all the other houses: every beam weighed over a ton, the foundations were cyclopic blocks of granite.

Shortly before the war, I remember him showing me the plan of a huge building.

'What's this building?' I asked

'It's not a building, it's a desk,' Andreyev replied.

It turned out that he had commissioned the design for a multi-storeyed desk from an architect: an ordinary desk was too restricted and small for him.

This penchant for the enormous, the magnificent, the splendid revealed itself at every turn. The hyperbolic style of his books was matched by the hyperbolic style of his life. Not for nothing did Repin call him 'Duke Lorenzo' [after the hero of his play *The Black Maskers*]. He should have lived in a gilded castle and walked about on luxurious carpets attended by a brilliant entourage. That would have suited him, it was as if he had been born to it. How majestically he appeared before his guests on the broad ceremonial staircase, leading from the study to the dining-room! If music had struck up somewhere at that moment, it would not have seemed strange.

●

His house was always full of people: guests, relatives, a large staff of servants, and children, lots of children, both his own and others' – his temperament required an expansive and abundant life-style.

His handsome, dark, finely-chiselled, decorative face, his well-proportioned, slightly heavy figure, his imposing, light step – it was all in harmony with the role of a majestic duke, which he played so brilliantly towards the end. That role was his tour de force, he merged with it organically. He was one of those talented, ambitious, pompous people, who long to be the captain on every ship and the bishop in every cathedral. He could not bear to take second place in anything, even in a game of skittles, he wanted to be the one and only. He was born to walk at the head of a magnificent procession, lit by torches, and with bells ringing.

•

In everything that surrounded and reflected Andreyev there was something decorative, theatrical. The whole decor of his house sometimes seemed to have come from the property department; and the house itself, in the Norwegian style, with a tower, seemed to be the invention of a talented director. Andreyev's costumes suited him like those of an operatic tenor – the costumes of an artist, a sportsman, a sailor.

He wore them like actors wear costumes on stage.

•

He involuntarily took on the voices and gestures of the characters in his works, their whole soul, and was transformed into them, like an actor.

•

That is why there are so many contradictory opinions of him. Some said he was arrogant, others that he wore his heart on his sleeve. One would find him in the role of 'Savva', when he visited him. Another would come across a student from the comedy *Days of Our Life*. Yet another – the pirate Khorre. And each of them thought this was Andreyev. They forgot that before them was an artist who wore dozens of masks, who sincerely and with total conviction considered every one of his masks was his face.

There were many Andreyevs, and every one was genuine.

I did not like some Andreyevs, but the one who was a Moscow student appealed to me. He would suddenly become boyishly mischievous and jolly, would bubble over with jokes, often bad ones, but nice in a homely way, would compose nonsensical verses.

•

But often this gaiety, like everything else with Andreyev, was excessive and resembled an attack. It made you feel ill at ease and you were glad when it finally passed.

After one of these attacks of gaiety he became gloomy and usually began delivering monologues about death. This was his favorite topic. He pronounced the word *death* in a special way – very distinctly and sensually: *death*, just like some voluptuaries pronounce the word 'woman'. Here Andreyev displayed great talent: he was better than anyone else at fearing death. It is no easy matter to fear death; many try, but they do not achieve anything; Andreyev succeeded splendidly; that was his true vocation: to experience the despair and horror of death. This horror can be felt in all his books, and I think it was precisely this horror he was trying to escape from when he grasped at colour photography, gramophones, painting. He needed something or other to screen himself from his sickening bouts of despair.

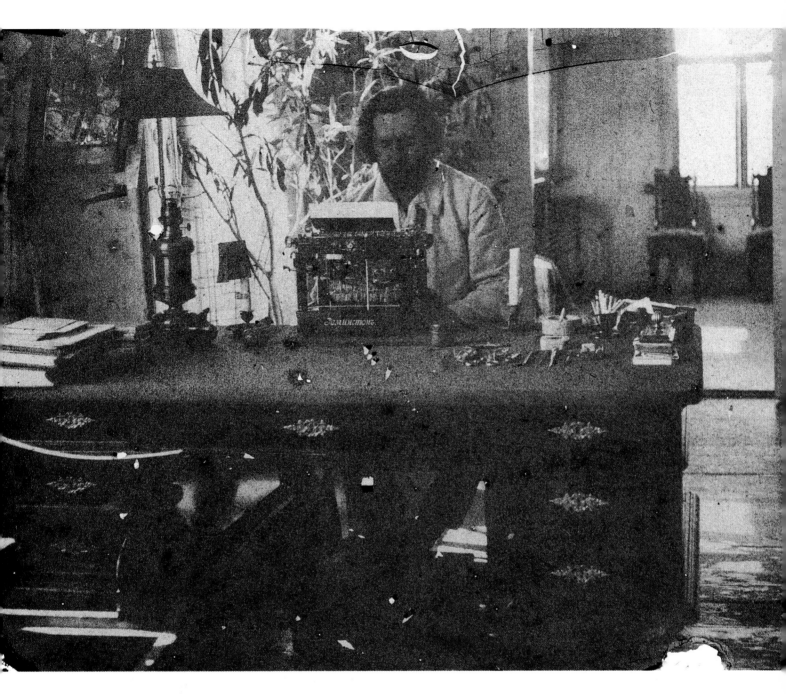

1 ANDREYEV the 'modern' writer at his Remington typewriter, in the study of the summer home he rented in 1913 on the island of Koivisto (Björkö; now Primorsk) along the coast of the Gulf of Finland to the west of Vammelsuu.

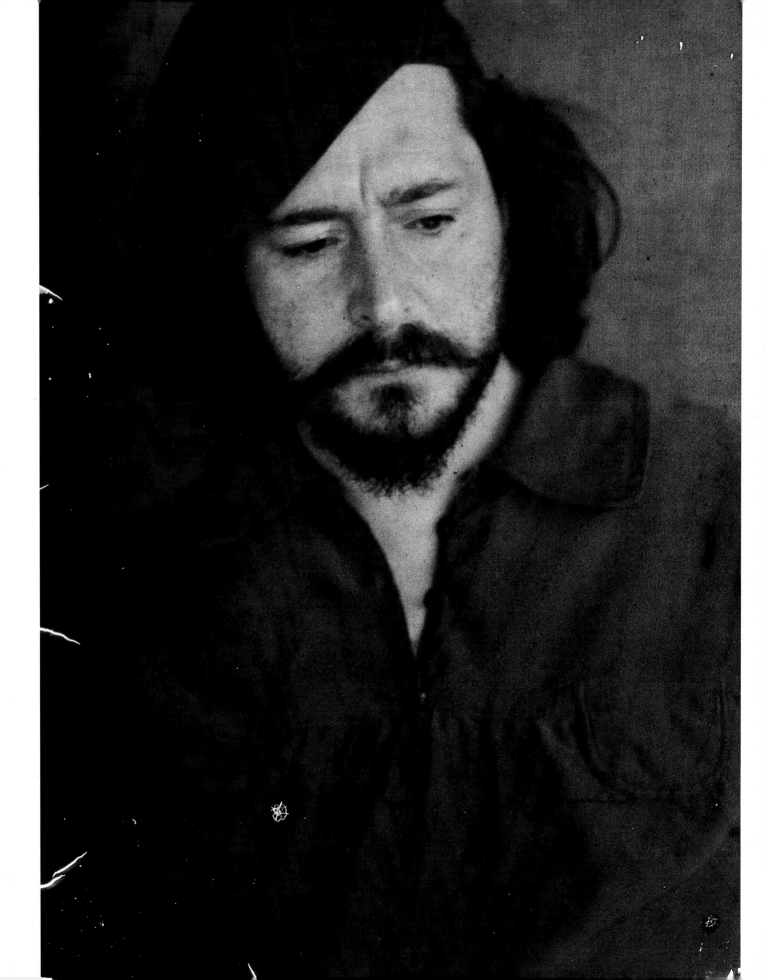

2 'Wearing a red beret': a dramatic image of the artist preoccupied with the eternal questions of existence. Andreyev copied this photograph for a self-portrait which was reproduced in an article about his paintings in the January 1912 issue of the illustrated magazine *The Sun of Russia*.

3 A nude portrait of Anna Andreyeva, photographed in the study at Vammelsuu. Though intensely personal, the composition is influenced by academic painting.

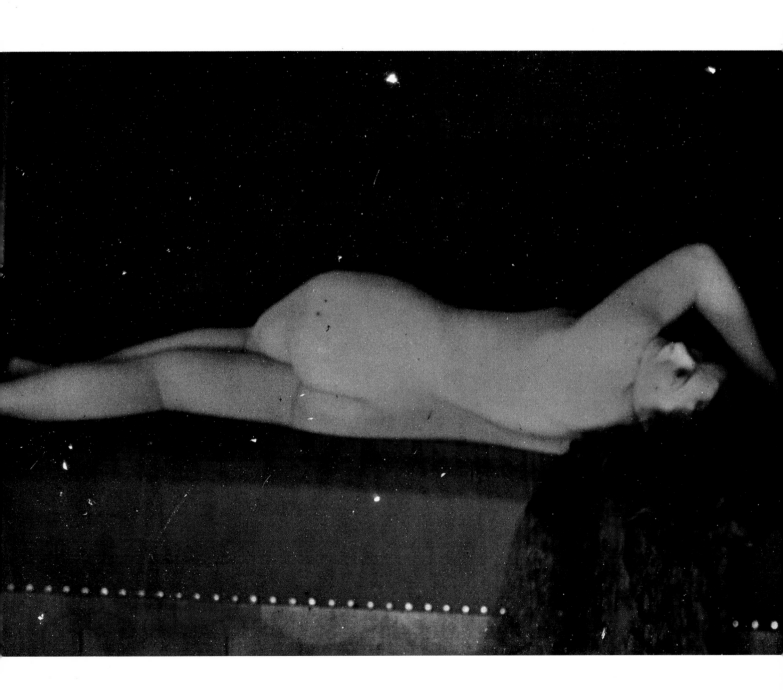

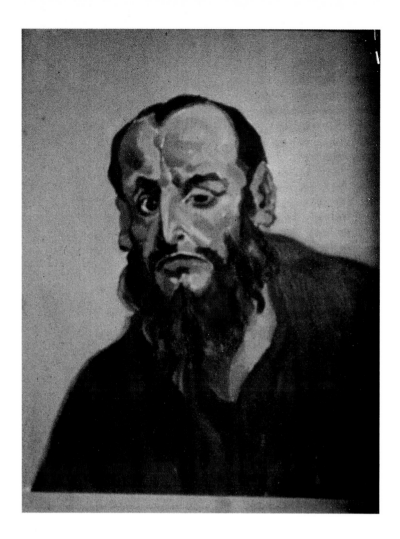

4 ANDREYEV'S PORTRAIT of Judas Iscariot. When reproduced in *The Sun of Russia* this was accompanied by an extract from his 1907 story *Judas Iscariot and the Others* describing how Judas' face was split into two halves: 'One side, with its sharply scrutinizing black eye, was alive and mobile and readily gathered into a multitude of crooked wrinkles, while on the other side there were no wrinkles and it was deathly smooth, flat and motionless; and although it was the same size as the first side it seemed enormous on account of its wide-open blind eye.'

5 'THE MYSTERIOUS HEAD'. Andreyev made a series of experimental photographs in which double exposures were used to create phantom disembodied heads, as in this self-portrait, or ghostly figures standing against furniture which shows through their 'ectoplasmic' outlines.

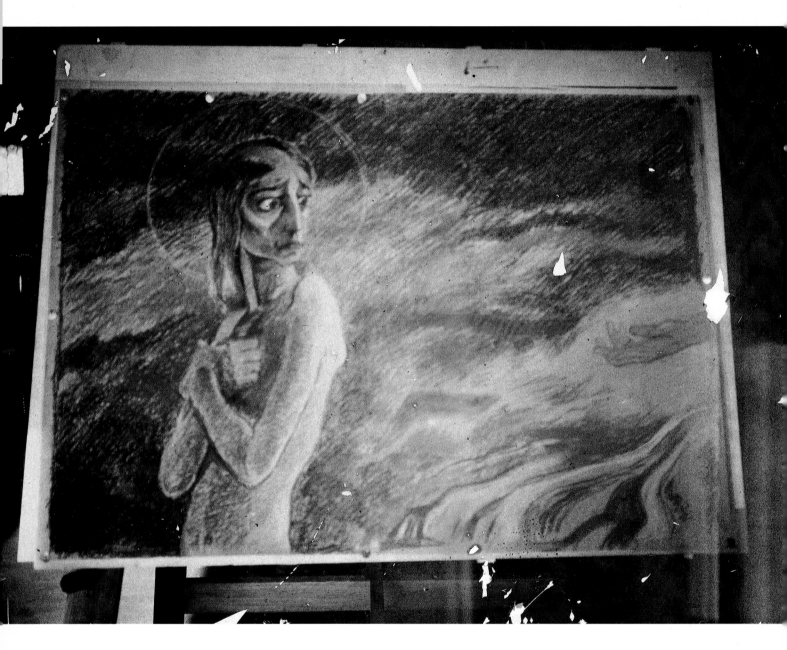

6 THE INSPIRATION behind this sinister painting is unclear, but its subject – a fallen angel resisting final commitment to Satan, whose hand beckons him? – is reminiscent of Andreyev's earliest unpublished stories, peopled by good and evil spirits moving about an intergalactic landscape, and of the opening and closing scenes of his play *Anathema*.

7 'LEONID AND THE DEVILS'. Andreyev made enlarged copies of Goya etchings to decorate his study, and in 1904 he had planned to illustrate *The Red Laugh* with reproductions from Goya's *Los Desastres de la Guerra*. Several of his contemporaries noted the similarity between his and Goya's sardonic use of the grotesque to expose hypocrisy and spiritual bankruptcy. Goya's inscription to this engraving from *Los Caprichos* is: 'To have long nails is so disadvantageous and harmful that it is forbidden even among witches.'

Overleaf:
8 THE CRUCIFIX with which Andreyev is posing in this startling mock-sacrilegious tableau usually hung in his study.

9 'MUNICH – CATHEDRAL INTERIOR': an essay in menacing gloom, presided over by the suspended crucifix.

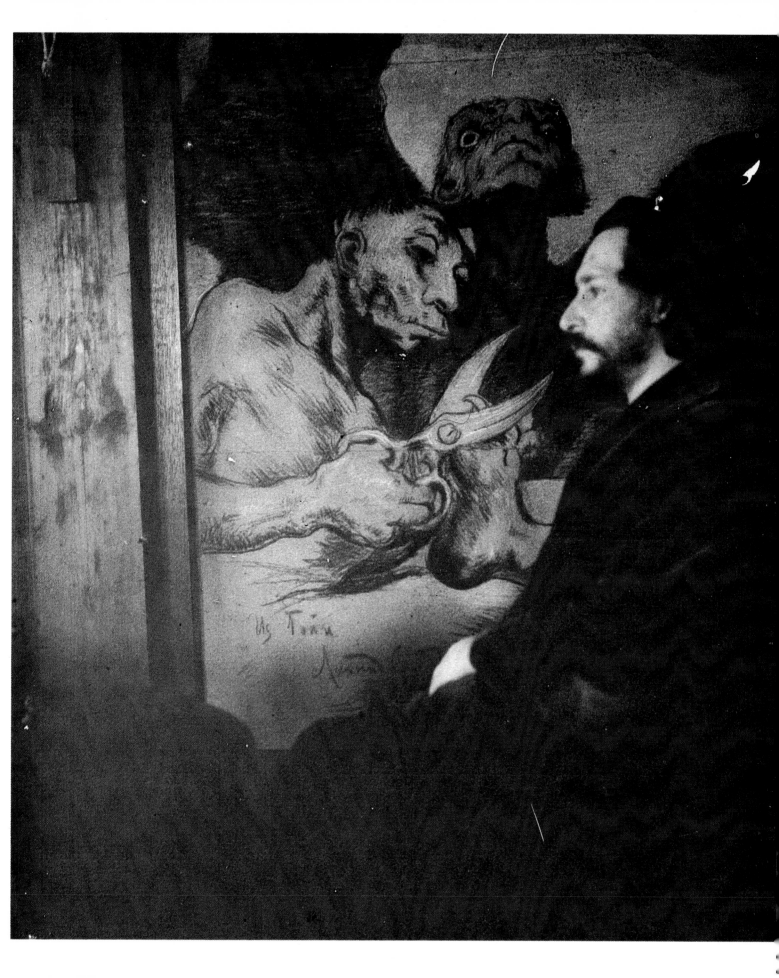

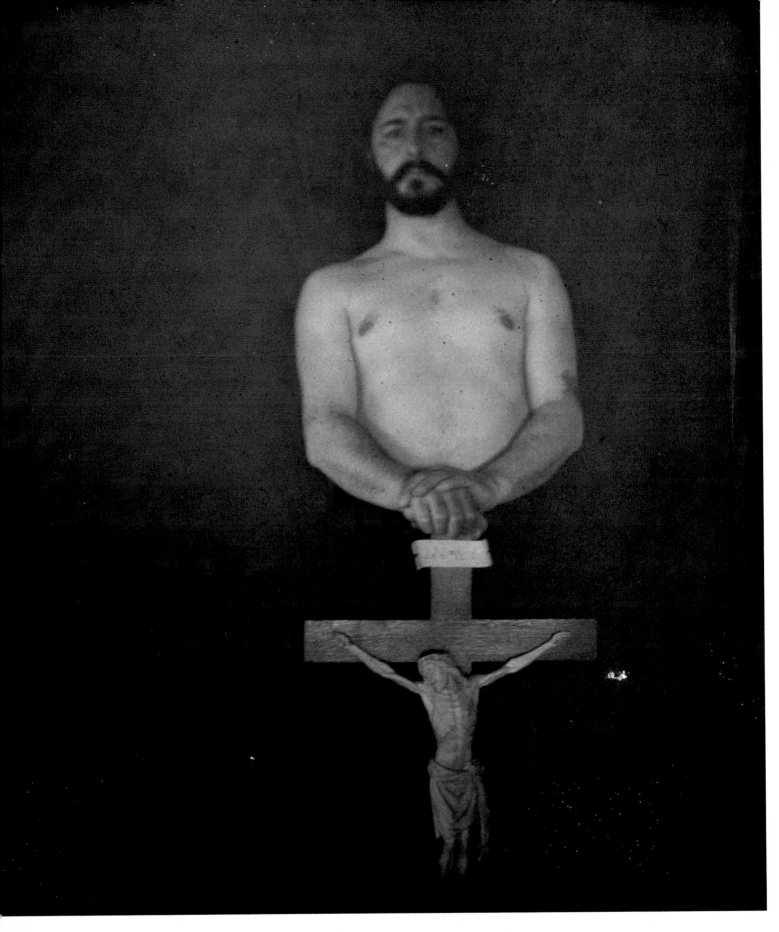

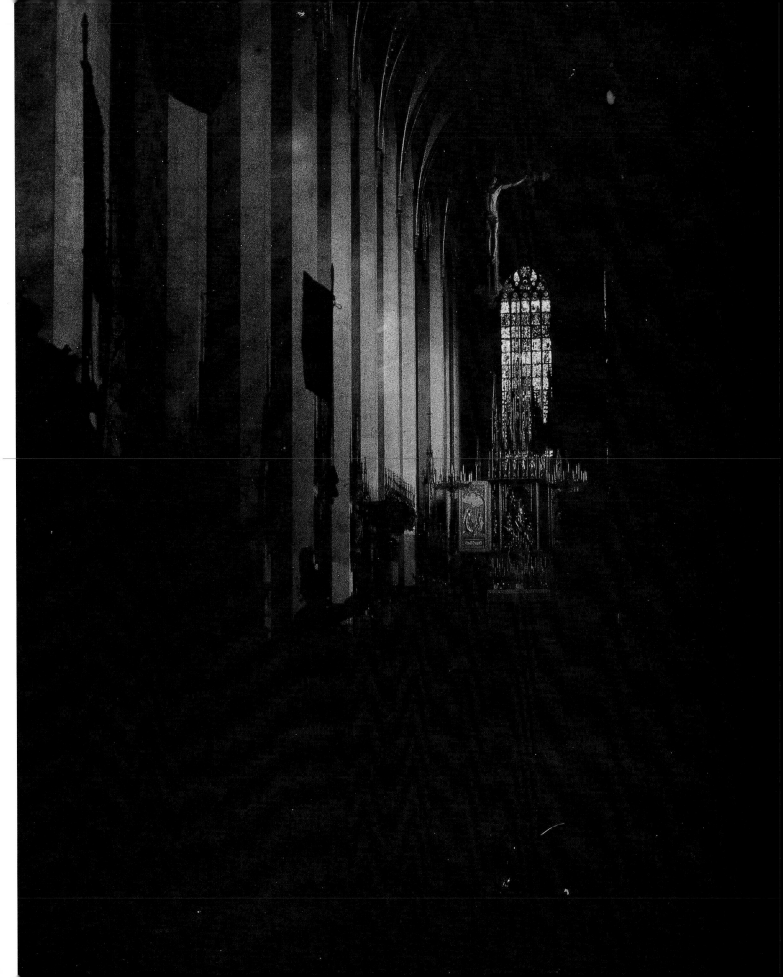

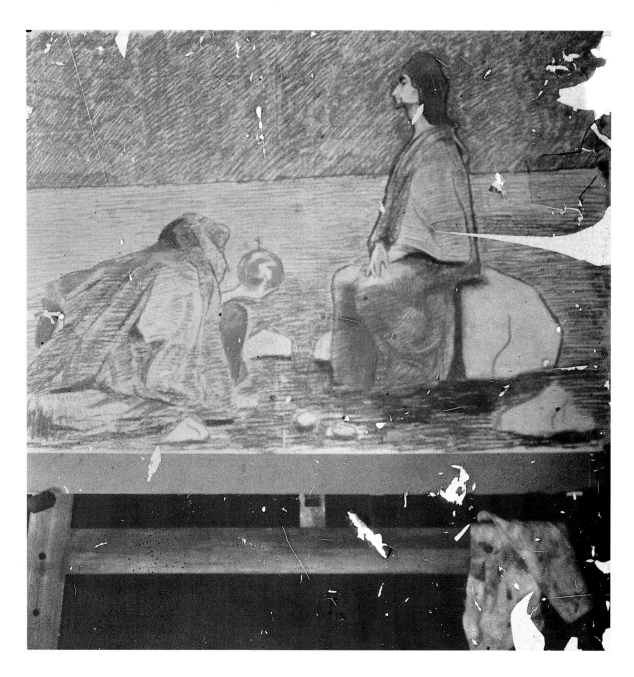

10 ANDREYEV was not a believer, yet in both his writing and his photography
and painting he frequently drew on the Christian tradition for subject-matter,
which he invariably treated in an unorthodox fashion. This painting depicts
Christ in the wilderness being tempted with wordly power by Satan.

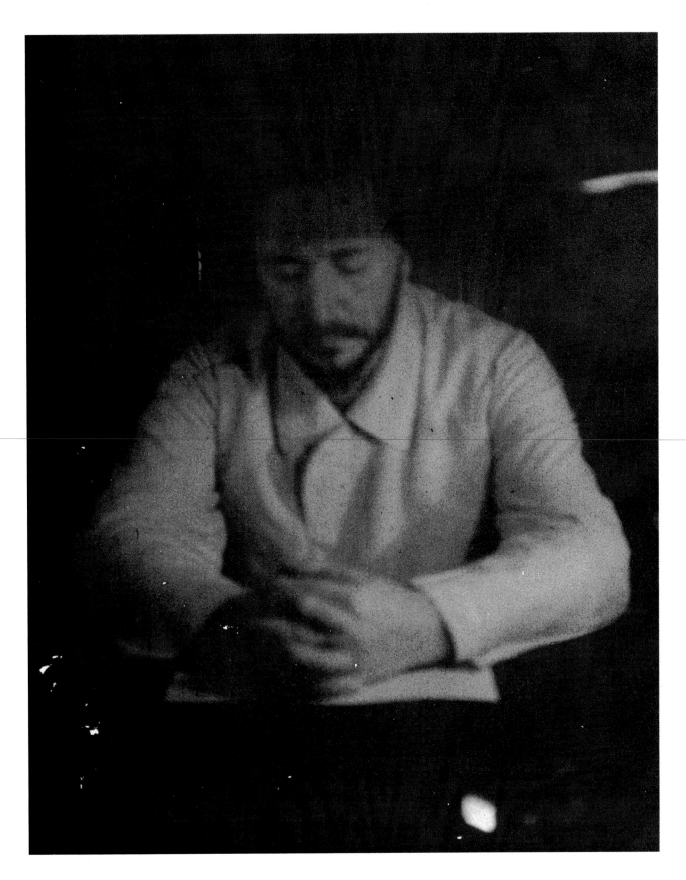

11 ANDREYEV MEDITATING over a book in his study.

12 'THE FIREPLACE'. The 'Celtic' decoration on the fireplace in Andreyev's study was typical of the so-called Northern style employed by the architect, Andrei Ol. Part of one of Andreyev's paintings can be seen on the left.

13 'BY THE STOVE'. Andreyev in one of the bedrooms of his Vammelsuu home.

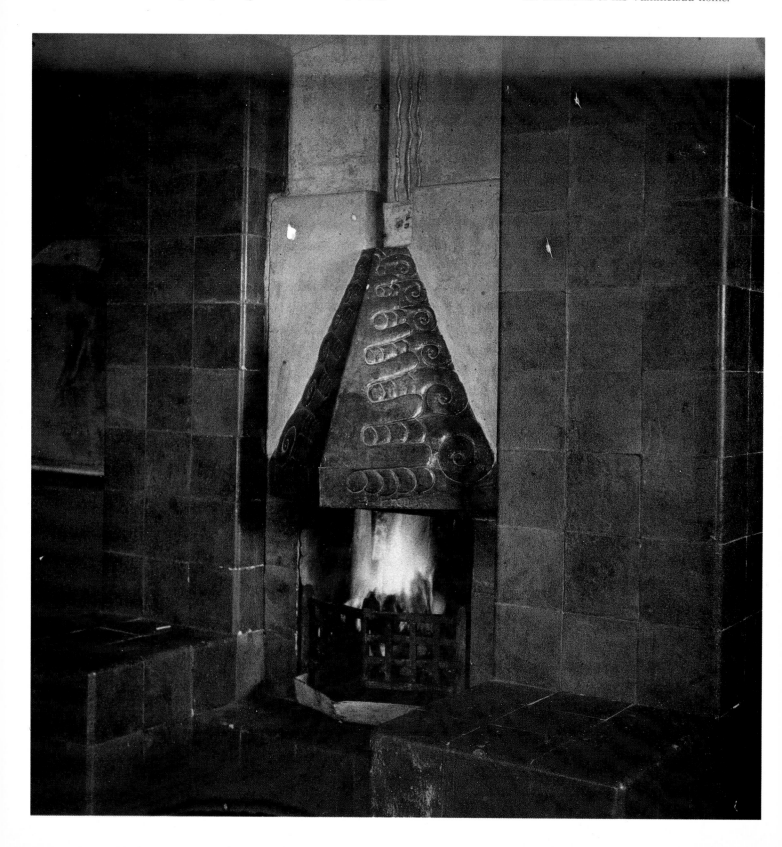

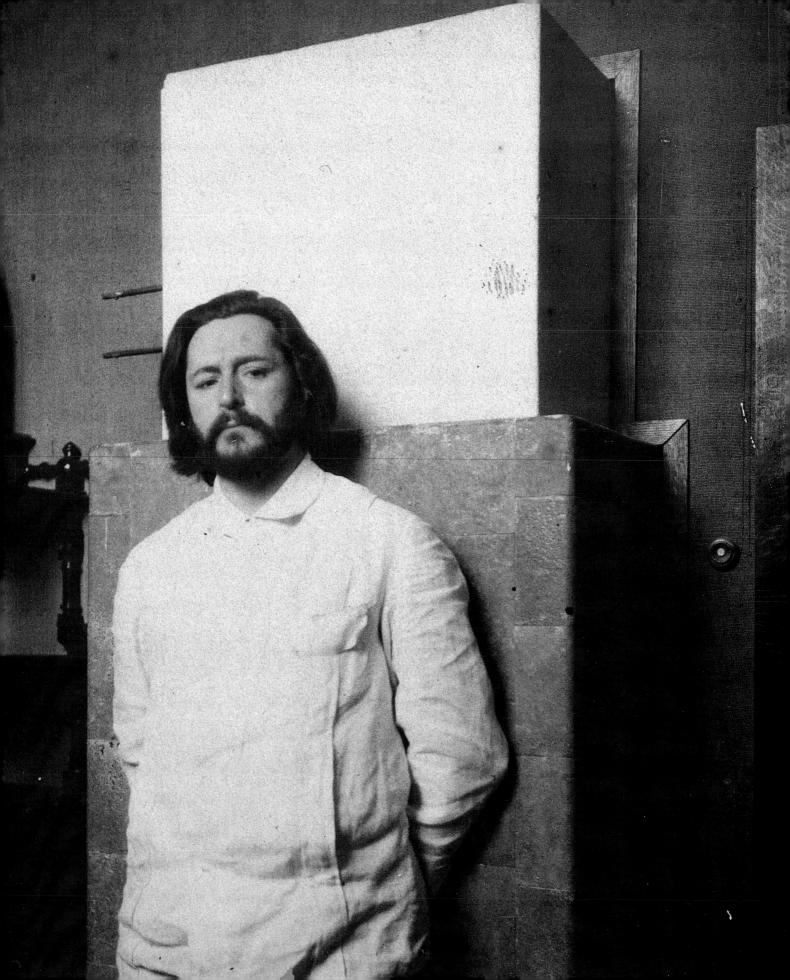

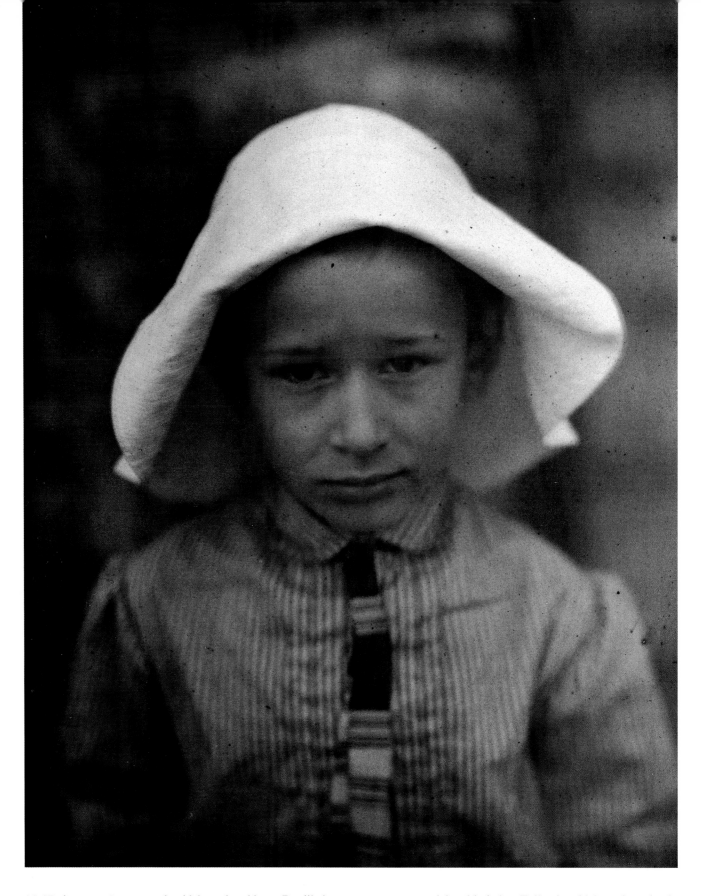

14, 15 ANDREYEV'S TWO SONS by Aleksandra. Above: Daniil, the younger, on a rare visit to his father. Following Aleksandra's death, Daniil was brought up by her family in Moscow. Right: Vadim, the elder son, reveals here some of the anguish and frustration he experienced after his father's second marriage had raised a barrier between them (see p. 52).

16 'In an armchair. May 1910'. Vadim sitting in one of the specially designed chairs Andreyev commissioned for the Vammelsuu house.

17 'In the study'. Vadim sitting on the arm of one of the massive wall-couches in Andreyev's study.

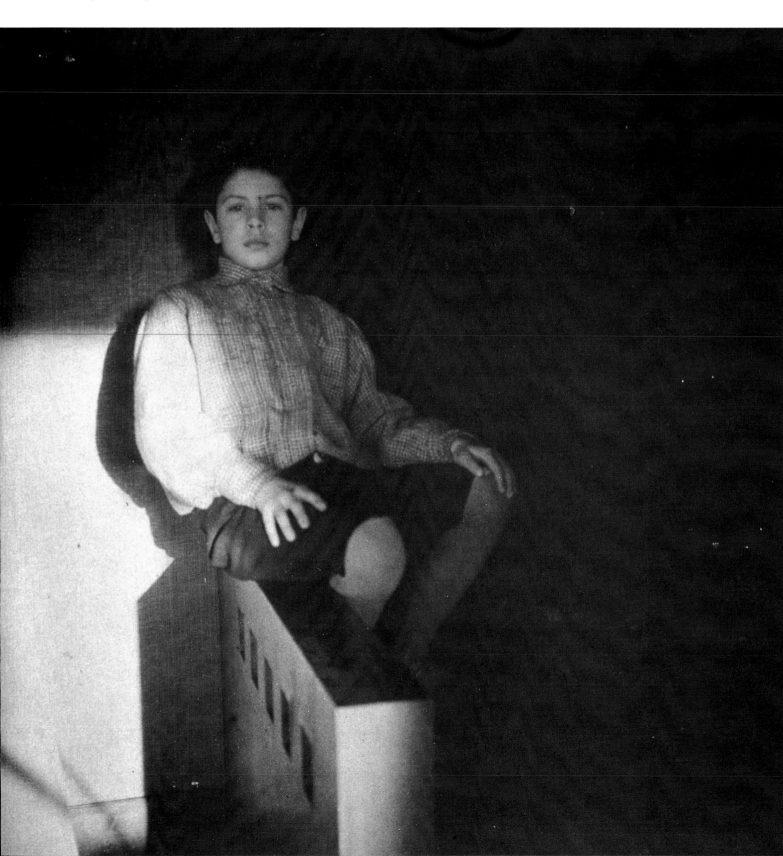

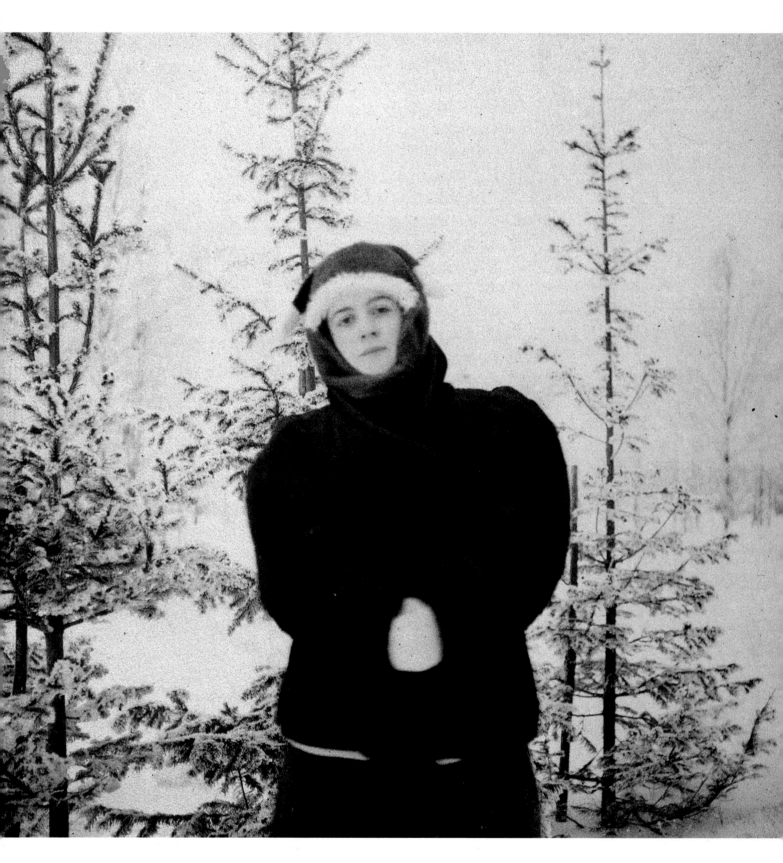

18 'WINTER ANNA'. Anna Andreyeva in the garden of the Vammelsuu house.

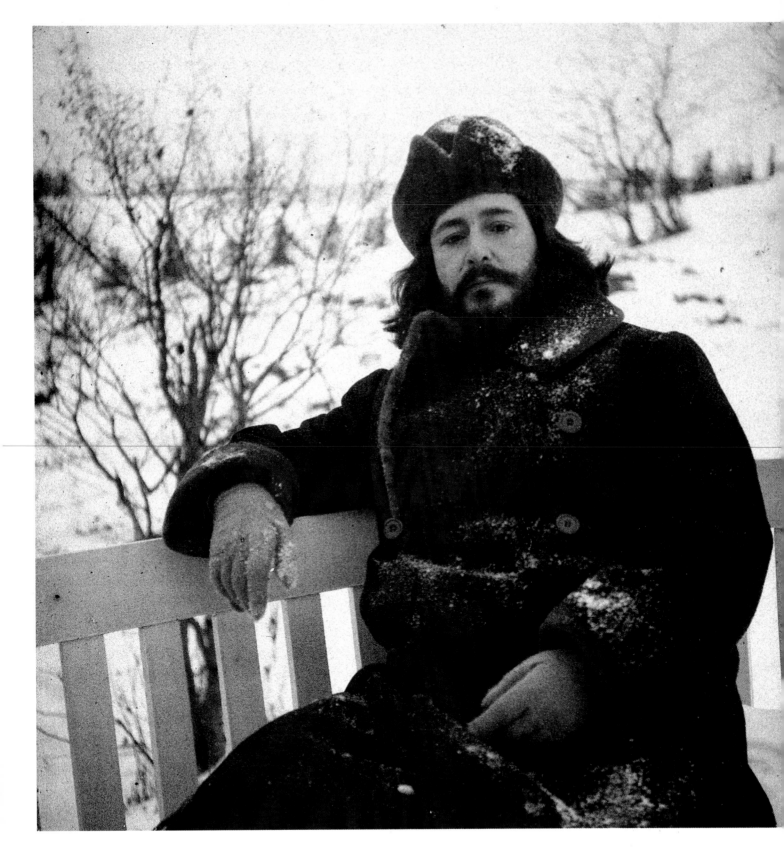

19 'IN WINTER ON THE ROUND BENCH'. Andreyev in the garden of the Vammelsuu house.

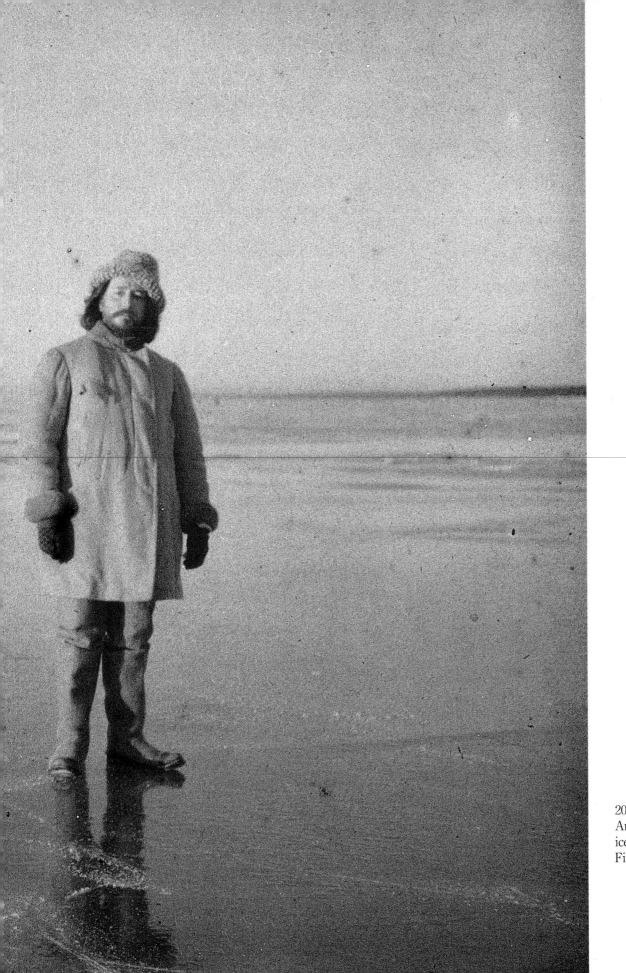

20 'Leonid on the ice'. Andreyev standing on the ice of the frozen Gulf of Finland.

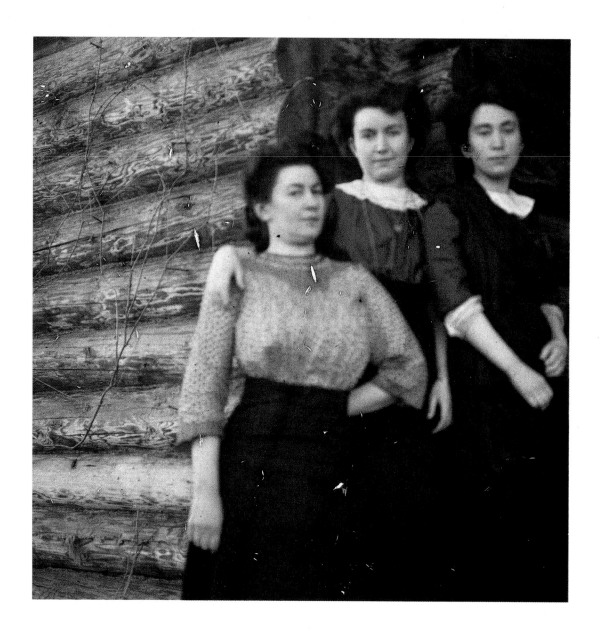

21 'THE THREE GRACES'. Three unidentified young visitors to the Vammelsuu house.

22 NATALIYA ANDREYEVA was the wife of Andreyev's brother, Vsevolod. Their son, Igor, died in 1912, and during and after Vsevolod's long terminal illness Natalia lived at Vammelsuu and assumed much of the daily responsibility for the children.

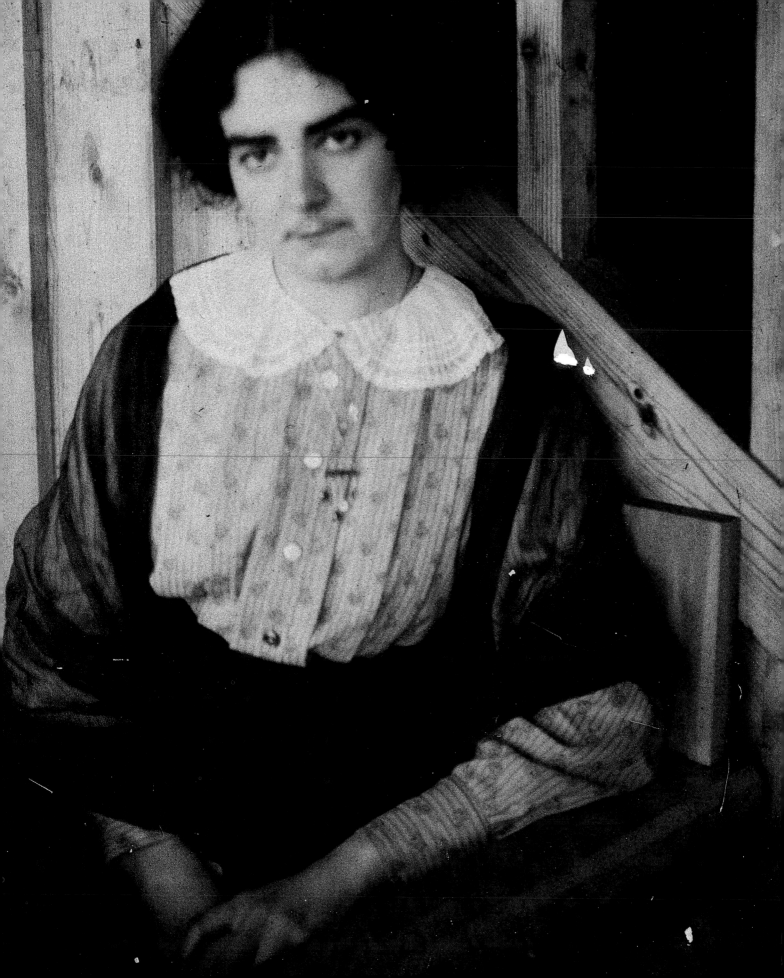

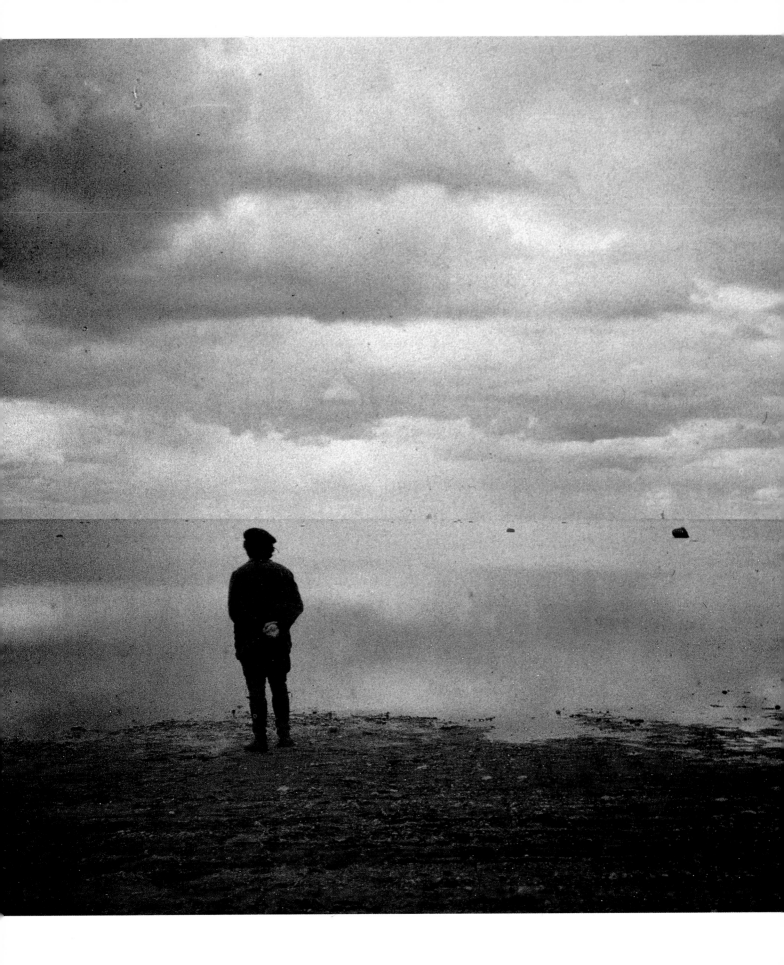

II The recovery of happiness

23 'BY THE SEA, CALM'. Andreyev contemplating the becalmed Gulf of Finland in a scene reminiscent of a stage direction from his play *The Ocean*: 'Right by the sea, on the narrow strip of stony shore stands a man – a small, dark motionless spot. . . . Today it is calm and – as always – alone. . . The man standing as usual in his habitual place at the very edge of the abyss.'

When in 1908 Andreyev married for the second time, moved to Vammelsuu on the Gulf of Finland and settled down in his newly-built house in the country, he was realizing a long cherished dream. The house was designed by a young architect, Andrei Ol, who had trained under Saarinen, but its inspiration was all Andreyev's own. What it meant to him – its symbolic and psychological significance – can be gauged from an excerpt from his play *The Life of Man*, completed in Berlin in September 1906, shortly before Aleksandra's death and inscribed: 'To the radiant memory of my friend, my wife, I dedicate this work, the last that we worked on together.' The second act depicts the hero, a young architect battling for recognition of his talent and struggling to make ends meet, dreaming with his wife of the house they will live in when success arrives:

Man. What I plan is to build a castle in Norway, in the mountains. Down below is a fiord, with a castle high above on a jagged mountain. Have you got any paper? No? Well, look at the wall, I'll show you there. This here is the fiord, all right?

Wife. Yes. How beautiful!

Man. Sparkling deep water, here it reflects the tender green grass; here the red, black and brown rocks. And here in the opening – where this stain is – there's a patch of blue sky with a little white cloud moving slowly across it . . .

Wife. Look, a white boat is reflected in the water like two white swans floating breast to breast.

Man. And here the mountain starts going up. Merry and green at the bottom, it gets gloomier and gloomier as it goes up, more and more severe. Jagged cliffs, black shadows, torn, ragged clouds . . .

Wife. Like a ruined castle.

Man. And here on this stain in the middle I'll build a castle fit for a king.

Wife. It's cold there! And windy!

Man. I'll have thick stone walls and enormous plate-glass windows. At night, when the winter storms are raging and the fiord is roaring down below, we'll draw the curtains and stoke up the fire in the enormous fireplace. Our fireplaces will be so enormous that whole great beams will burn in them, whole forests of pine-trees dripping with resin.

Wife. How warm!

Man. And note how quiet, too. There are carpets everywhere and lots and lots of books, which make the silence so alive and warm. And we are alone together. Outside the storm rages, while we are together in front of the fire on a white bearskin. 'Shall we have a look what's going on out there?' you ask. 'Yes, let's,' I answer, and we go up to the largest window and pull back the curtain. My God, what a sight!

Wife. Snow is swirling everywhere!

Man. Like white horses racing past, like myriads of frightened little spirits, pale with terror, begging the night to rescue them. And screaming and howling . . .

Wife. Brr, it's cold! I'm shivering!

Man. Quickly, back to the fire! You there, bring me my grandfather's goblet. No, not that one – the golden one the Vikings drank from! Fill it with golden wine, no, not like that – let the

burning liquid come right up to the brim. There's a chamois roasting on the spit – bring it here, I'll devour it!

Now the house was built and, as his photographs show, it was no conventional home. Everything about it reinforced the impression of security, comfort and permanence. Man's dream was to be made real. With Anna, Andreyev found happiness again. The house became the setting for all those pastimes, interests and activities that he most loved – boating, entertaining friends, photography.... Shortly before his own death, in a diary entry for 8 December 1918, he reflected on Anna's place in his life:

My relationship with Anna is a subject of such enormous importance and seriousness that I can only bring myself to approach it with difficulty. It is almost the same as if I wanted to define my whole relationship and relations with life, or – as I was asked by one lady-reader – to explain in a few words the meaning of my works. And in general I write little about my relationship with Anna: 1) because in general I do not write here about the most important things and 2) I talk about it too much with Anna herself, and I say everything to her, without the need to carry anything over into secret documents. My individual brief observations are merely the temperature-reading on a given day – the weather as opposed to nature itself.

Now, when I am filled with such turmoil, I shall try in all conscience to answer precisely and to the point. Do I love Anna? Yes. I love her very much indeed, deeply and strongly; to lose her would be unthinkable and dreadful for me, I could only part from her under one circumstance: the disappearance of love on her part. As someone who belongs to everyday life she arouses in me a negative response, which at times grows into a special kind of everyday hatred. But everyday life is only one side of her, and moreover her least important side: with her other side she enters my soul and constitutes an inseparable and essential part of it. Here she is my best and only friend, with whom I always find it interesting and important to talk, whether about life, or about my works and plans. Whenever I see something, my first wish is to discuss it with Anna; only when it has passed through Anna does what I have seen, experienced and thought become a fact of my soul. Without that it is just a dream and swift oblivion.

But I am not *in* love with her, that would be impossible, just as you do not find fruit and flower on one branch. At the same time the mere thought that Anna might be unfaithful or not love me can *instantly* drive all other feelings out of me and bring me to a state of madness. She is the only person I could kill and have killed in my thoughts. The only one!

Andreyev's letters to Aleksandra and Anna, of which some three hundred have survived, show him to have been, as this diary entry suggests, an extremely demanding lover and husband, and his violently passionate and categorical emotions were a source of much anguish to those nearest to him. His eldest son, Vadim, has left a moving account of his struggle to re-establish contact with his father after his second marriage:

Throughout my childhood, from the ages of five to fourteen, my father remained alien and distant. But whereas for me he continued to exist as a transparent and insurmountable wall, for him I almost completely ceased to exist, it was as if he did not notice me or my efforts to approach him. It is very hard for me to explain how this estrangement came about. There were probably many intangible and inexpressible reasons. But there were two definite and clear ones: firstly, my father only liked little children, up to the age of five. The only exception was my brother Savva, Anna Ilinichna's first son, whom my father loved without any interruptions right up to the day of his death. In general he had strange, atavistic reasons for his love or aversion for people, and in that respect he was frequently cruel and unjust. . . . The second reason, which I find it very hard to talk about, for fear of being unjust myself, was Anna Ilinichna.

From the very beginning of our life under the same roof . . . I started avoiding Anna Ilinichna, but avoiding and hiding from her was as far as it went, for there was no open aversion involved. Her presence upset me, I became gloomy and resentful and, without understanding it myself, turned into a step-son. When she came into the nursery, I stopped playing, crept unnoticed into a corner and waited in agony until she left. Anna Ilinichna involuntarily taught me to lower with restless, distrustful eyes. Everything about her caused me pain – her voice, her inability to show tenderness, her abrupt movements. I do not remember whether she made any attempts to bring me closer to her – perhaps she did – but if so she was not persistent enough to conquer my distrustfulness, which merely increased day by day. And when Savva was born, she completely forgot about both Nina [her daughter by a previous marriage] and me, devoting herself to him heart and soul, with all the passion of a Biblical love for the first son. This love completely absorbed her – for the whole of the rest of her life. For a long time no-one apart from my father and Savva existed for her. She unwittingly focussed my father's whole attention on Savva, and not only I, but her other children as well, were left in the shade and entrusted to the care of nurses, tutors and governesses. . . .

I was jealous. When Pasha, the cunning, smooth-tongued, nasty nurse, who ruled the roost in the nurseries after Savva's birth, talked in my presence about 'the favorite son', I could have screamed and wept, but I did not either scream or weep and kept my resentment and pain to myself. Occasionally, at the end of my tether, I would attempt to approach my father, but we no longer had a common language: he did not understand me, could not feel what it was that brought me to him, told me indifferently and absentmindedly to go and play in the nursery.

The similarity in spirit between Man's mountain-top castle in Norway and the house that Andreyev built at Vammelsuu was noted by many of his contemporaries. Among the first of the countless journalists to call on Andreyev in his new home was Herman Bernstein, whose subsequent article in *The New York Times* revealed a side of Andreyev that could hardly be mentioned, because of censorship, in Russian publications of the time, namely his political views:

As I drove from Terioki to Andreyev's house, along the dust-covered road, the stern and taciturn little Finnish driver suddenly broke the silence by saying to me in broken Russian:

'Andreyev is a good writer. . . . Although he is a Russian, he is a very good man. He is building a beautiful house here in Finland, and he gives employment to many of our people.'

We were soon at the gate of Andreyev's beautiful villa – a fantastic structure, weird-looking, original in design, something like the conception of the architect in *The Life of Man*.

'My son is out rowing with his wife in the Gulf of Finland,' Andreyev's mother told me. 'They will be back in half an hour.'

As I waited I watched the seething activity everywhere on Andreyev's estate. In Yasnaya Polyana, the home of Count Tolstoy, everything seemed long-established, fixed, well-regulated, serenely beautiful. Andreyev's estate was astir with vigorous life. Young strong men were building the House of Man. More than thirty of them were working on the roof and in the yard, and a little distance away, in the meadows, young women and girls, bright-eyed and red-faced, were haying. Youth, strength, vigour everywhere, and above all the ringing laughter of little children at play. I could see from the window the 'Black Little River', which sparkled in the sun hundreds of feet below. The continuous noise of the workmen's axes and hammers was so loud that I did not notice when Leonid Andreyev entered the room where I was waiting for him.

'Pardon my manner of dressing,' he said, as we shook hands. 'In the summer I lead a lazy life, and do not write a line. I am even forgetting [how] to sign my name.'

I had seen numerous photographs of Leonid Andreyev, but he does not look like any of them. He has grown much stouter. Instead of the pale-faced, sickly-looking young man, there stood before me a strong, handsome, well-built man, with wonderful eyes. He wore a greyish blouse, black, wide pantaloons up to his knees, and no shoes or stockings.

At this point Andreyev's wife, a charming young woman, also dressed in a Russian blouse, came in. The conversation turned to America, and to the treatment accorded to Maxim Gorky in New York.

'When I was a child I loved America,' remarked Andreyev. '. . . I was always planning to run away to America. I am anxious even now to visit America, but I am afraid – I may get as bad a reception as my friend Gorky got.'

He laughed as he glanced at his wife. After a brief pause he said:

'The most remarkable thing about the Gorky incident is that while in his stories and articles about America Gorky wrote nothing but the very worst that could be said about that country, he never told me anything but the very best about America. Some day he will probably describe his impressions of America as he related them to me. . . .'

It was a very warm day. The sun was burning mercilessly in the large room. Mme Andreyev suggested that it would be more pleasant to go down to a shady place near the Black Little River.

•

We stepped into a boat. Mme Andreyev took up the oars and began to row. We resumed our conversation.

'How do I picture to myself this future?' continued Andreyev, in answer to a question of mine. 'I cannot know even the fate and future of my own child, how can I foretell the future of such a great country as Russia? But I believe that the Russian people have a great future before them – in life and in literature – for they are a great people, rich in talents, kind and freedom-loving. Savage as yet, it is true, very ignorant, but on the whole they do not differ so much from other European nations.'

Suddenly [Andreyev] looked upon me intently, and asked: 'How is it that the European and American press has ceased to interest itself in our struggle for emancipation? . . . Russia to-day is a lunatic asylum. The people who are hanged are not the people who should be hanged. Everywhere else honest people are at large and only criminals are in prison. In Russia the honest people are in prison and the criminals are at large. The Russian Government is composed of a band of criminals, and Nicholas II is not the greatest of them. There are still greater ones. I do not hold that the Russian Government alone is guilty of these horrors. The European nations and the Americans are just as much to blame, for they look on in silence while the most despicable crimes are committed. . . . Perhaps I do not know international law. Perhaps I am not speaking as a practical man. One nation must not interfere with the internal affairs of another nation. But why do they interfere with our movement for freedom? France helped the Russian Government in its war against the people by giving money to Russia. Germany also helped – secretly. In well-regulated countries each individual must behave decently. When a man murders, robs, dishonours women he is thrown into prison. But when the Russian Government is murdering helpless men and women and children the other governments look on indifferently. And yet they speak of God. If this had happened in the Middle Ages a crusade would have been started by civilized peoples, who would have marched to Russia to free the women and children from the claws of the government.'

Andreyev became silent. His wife kept rowing for some time slowly, without saying a word. We soon reached the shore and returned silently to the house.

The house at Vammelsuu was not just the centre of Andreyev's everyday domestic and social life, but it was also an expression of his personality. Probably no other Russian writer of his time could have afforded to build such an extravagantly large house, but, more importantly, no other writer would have considered doing so, since the self-image of the Russian intelligentsia precluded such open flaunting of material success. Andreyev's contemporaries were consequently fascinated by the house, and nearly all memoirists seek to convey something of its appearance and atmosphere. One of the most comprehensive descriptions is provided by Vera Beklemisheva, whose husband was one of Andreyev's publishers:

The tall, dark, beam-built house with its tower and tiled roof, bright red in the sun, stood open to all the winds and blizzards of Finland and looked heavy and gloomy. To the right, beyond

the garden, which had been planted with young trees, you could see the little houses of Vammelsuu village. To the left, across a ravine, lay a string of dachas.... Andreyev's land was bordered on the west by the fast-flowing, whimsically winding Black River. Its bank was so steep and precipitous that a staircase had to be built to get down to the boats and bathing-hut, and climbing back up again afterwards was an effort.

In the yard you were met by St Bernard dogs.

Not far from the house stood various outhouses. Behind them stretched fruit and vegetable beds.

The walls of the house were covered in wild vine, which had spread well. From the porch of solid granite slabs the visitor entered the hall. It was not actually a hall as such, but part of the dining-room, separated from the main part by thick cloth curtains. Two doors led from the hall: one to the nursery, the other to the kitchen and servants quarters. Other doors, also hidden by curtains, led to Anastasiya Nikolaevna's room and the Andreyevs' bedroom.

Parting the curtain, the visitor found himself in the dining-room, which was so vast that a hundred people could easily dine in it.

From the dining-room one door led to a second nursery, another onto a large covered balcony.

The nurseries, which faced the sun, were spacious, the furniture was white and the walls were made of light-coloured wood.

The dining-room was grey-blue. Even the tiles on the enormous stove matched the colour of the furniture. Over the sideboard hung Serov's painting *'Crows on the Cliffs'*. Opposite, in a large bay the length of the whole wall stood an enormous couch, with five square windows above it.

A broad staircase climbed gently to the first floor. Where it turned, a vaguely disturbing figure rose up before you in the semi-darkness. This was Leonid Nikolaevich's own charcoal and crayon drawing of 'Someone in Grey' [from *The Life of Man*], holding a candle in his hand.

On the second floor were the gym-room, a guest-room, Vadim's room, the study, the library and Anna Ilinichna's room.

The most remarkable room in the house was the study. Enormous, just like the dining-room below, it was built of dark-brown oak. Dark beams with rounded sides crossed the rough, grey ceiling; they made the room look higher and broke up the huge expanse of the floor.

The large desk was placed so that it could be approached from all sides. Set into the walls in the gaps between the oak cross-beams were large drawings copied by Leonid Nikolaevich in charcoal and crayon from Francisco Goya. One of them showed a devil having his toe-nails cut, another an old man with bat's wings attached to his shoulders writing something with a quill in a large book open on his knees.

In the same place there hung against the dark wood a white Catholic crucifix and rosary. The oak chairs with high Gothic backs, the enormous couch, the dark-blue cloth covering the floor, all give this room an atmosphere of gloomy solemnity. Only the square windows with their splendid plate-glass panes, the orange silk curtains and the sparkling snow or the soft azure of

the sky outside introduce a note of peace and warmth.

The library is right next to the study. They are only separated by a long, dark curtain from floor to ceiling. Rows of books stand in the unbroken line of shallow bookcases. Among them are the classics, art books and newly published literature.

It is quiet in the study: the cloth floor-covering and the heavy curtains muffle footsteps and speech.

A door leads from the study to a spacious open balcony, which looks like the deck of a ship. Here, when he had worked through to dawn, Leonid Nikolaevich would greet the sunrise.

Next to the study is Anna Ilinichna's room built of light-coloured pear-wood.

In summer the house was cool and pleasant, but in winter the enormous stoves devoured masses of wood and had difficulty in maintaining the right temperature, so that everyone who lived in the house went about in sweaters or wrapped themselves in warm shawls.

•

The enormous size of the dacha obliged [Andreyev] to employ a large staff of servants, as keeping the house clean and tidy was no easy task.

There was always someone or other visiting the dacha, and between fifteen and eighteen people usually gathered for dinner.

•

It seemed to me that there was only any justification for Leonid Nikolaevich himself – and then only one part of him – living in such peculiar surroundings. The other members of his family (his mother, brothers and sister) were genuine Russians with the distinctive approach to life they brought with them from Orel with its unhurried ways, from the fields and forests of Central Russia, from noisy, colourful Moscow with its multitude of churches, its broad accent and its pot-bellied samovars.

24 'AT DAWN BY THE HOUSE'. Andreyev outside the Vammelsuu house in one of many photographs to exploit the Autochrome technique's suitability for difficult light conditions.

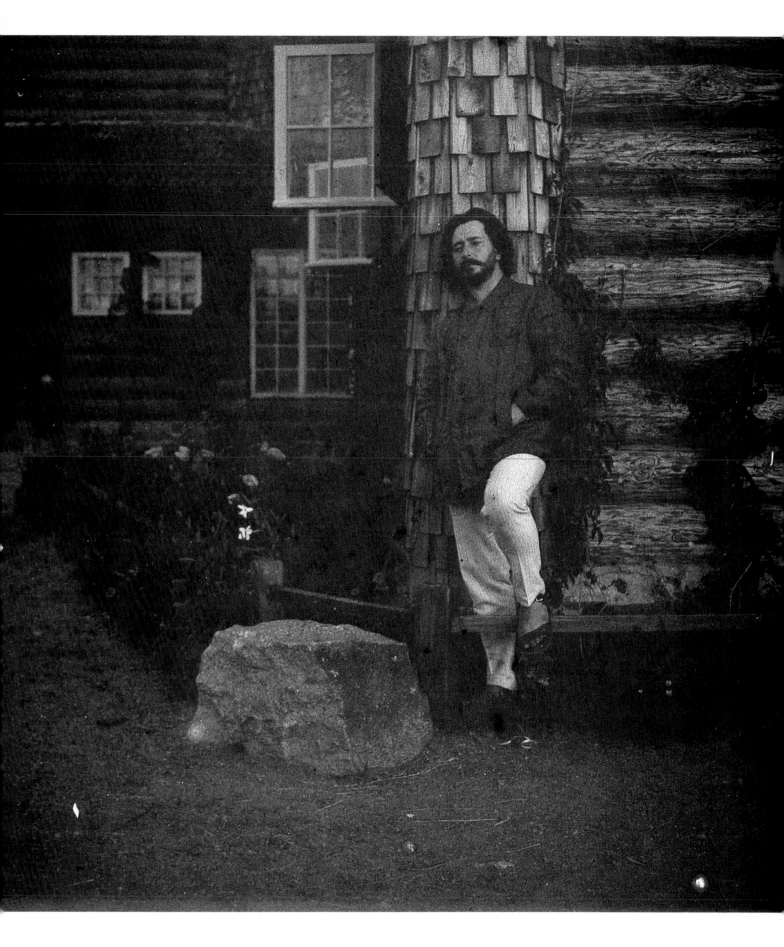

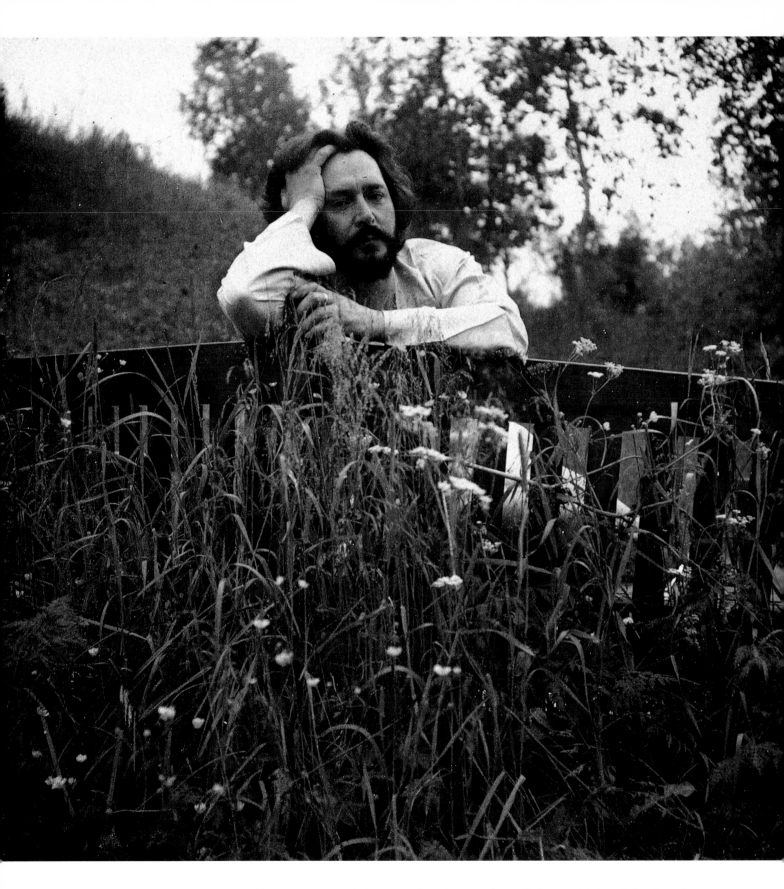

25 'Leonid on the round bench'. In this summer portrait (a companion piece to plate 19) the sensitivity of the Autochrome technique is demonstrated in the vibrant detail of every blade of grass and flower in the foreground.

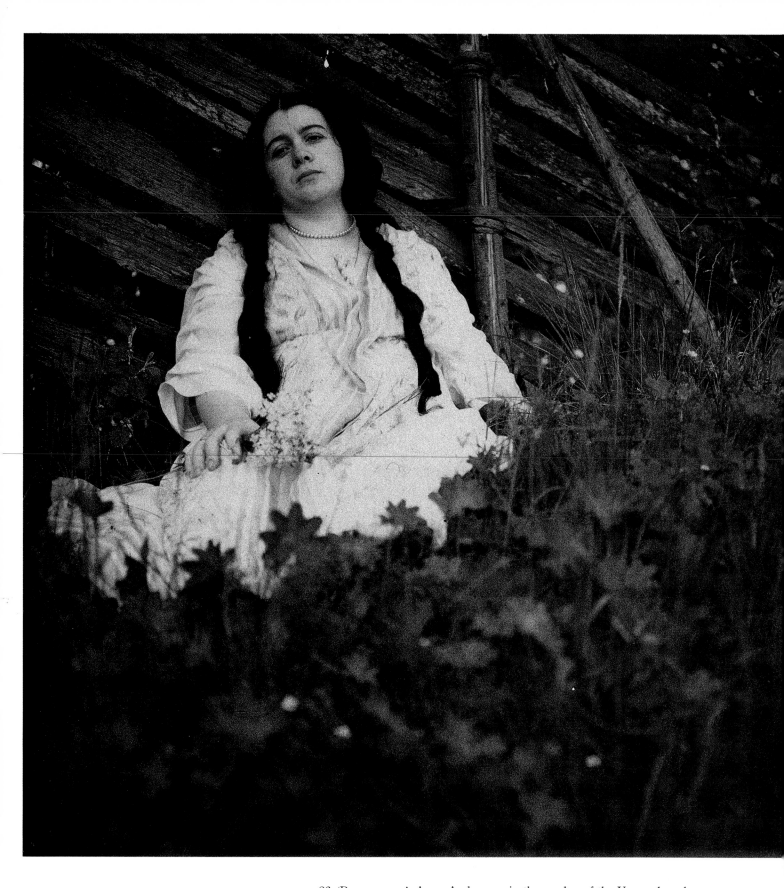

26 'By the fence'. Anna Andreyeva in the garden of the Vammelsuu house.

27 A LUNCHEON PARTY at
Vammelsuu, possibly
Anna's name-day
celebration. Anna
Andreyeva heads the
table, with (moving
clockwise) Andreyev, the
great artist Ilya Repin,
Andreyev's mother
Anastasiya, his sister
Rimma, Nataliya the wife
of his brother Vsevolod,
Vadim's tutor Mikhail
Petrenko, an unidentified
lady, Andrei Ol architect
of the Vammelsuu house
and second husband of
Rimma Andreyeva, Anna
the wife of Andrei
Andreyev, Andreyev's
youngest brother Andrei,
the wife of Andreyev's
publisher Mikhailov,
Nikolai Mikhailov
himself, and Repin's wife
Natalia Nordman.

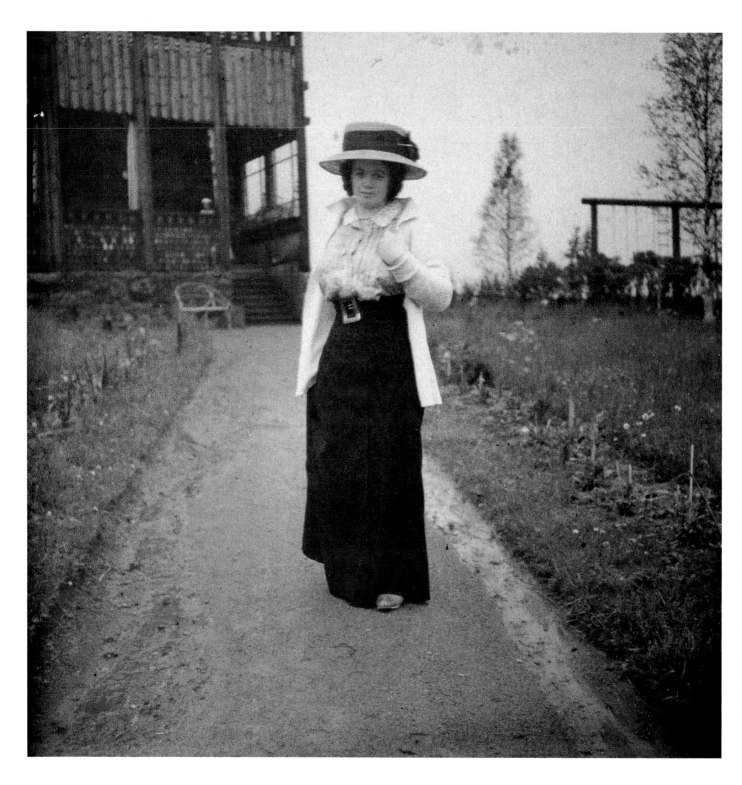

28 'ON THE MAIN PATH in the garden'. Anna Andreyeva in the garden of the
Vammelsuu house, which had to be replanted after most winters. To the
right are the children's swings.

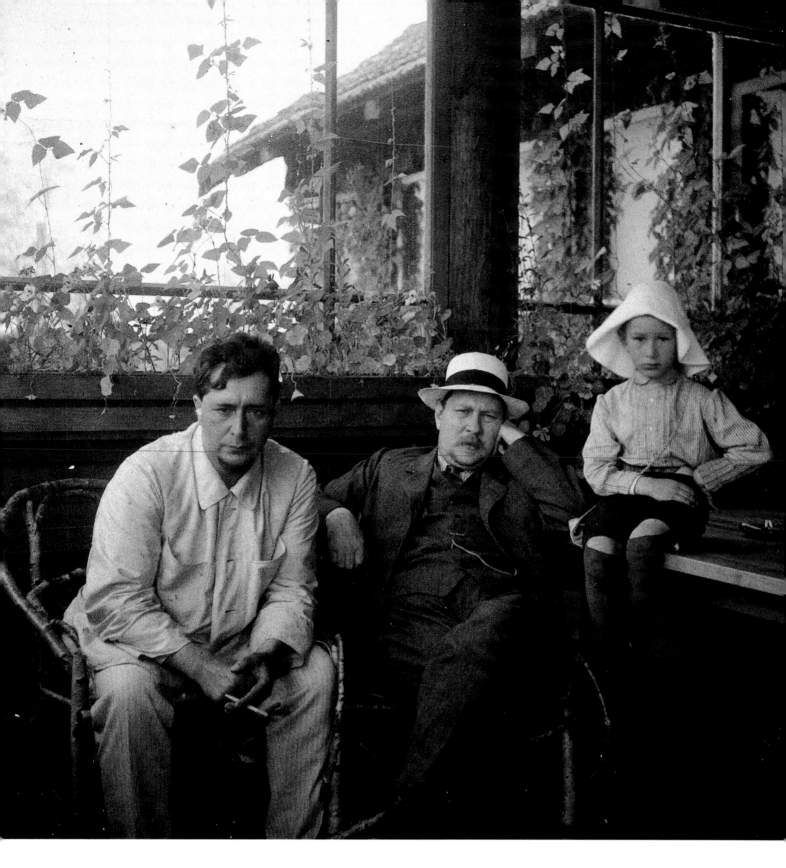

29 A CLEAN-SHAVEN ANDREYEV, with Filip Dobrov and Daniil in the dining area of the Vammelsuu house. Dobrov was a well-known and much-loved Moscow doctor and as the husband of Aleksandra's sister, Elizaveta, he was effectively Daniil's adoptive father.

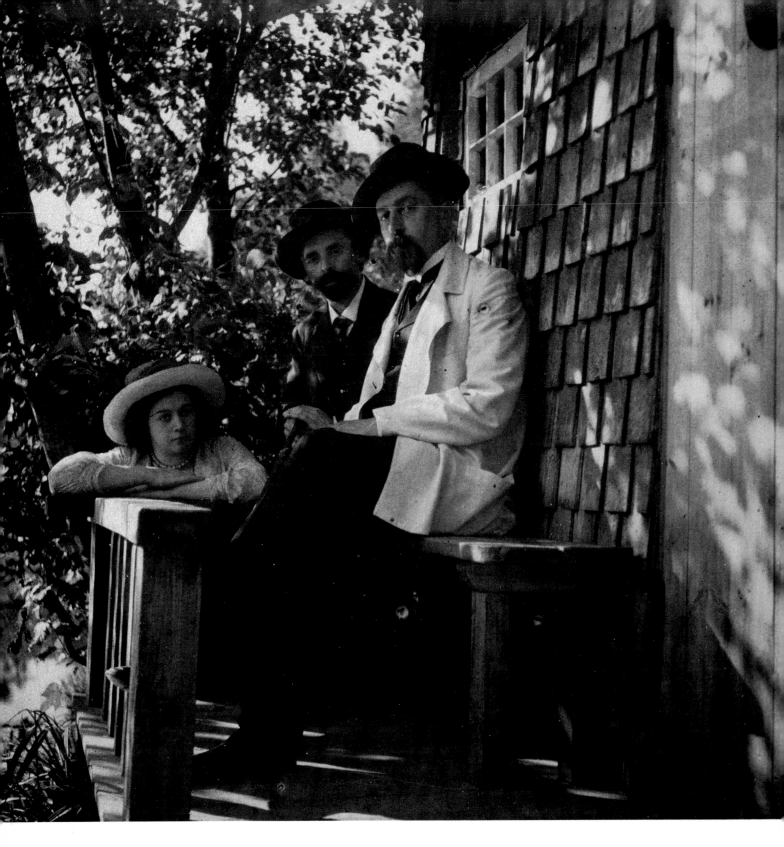

30 'WITH THE WRITERS'. Anna Andreyeva, Ivan Belousov and Nikolai Teleshev outside the changing-cabin on the Black River below the house. Teleshev was the organizer of the 'Wednesday' meetings in Moscow at which Andreyev cut his literary teeth in the early 1900s.

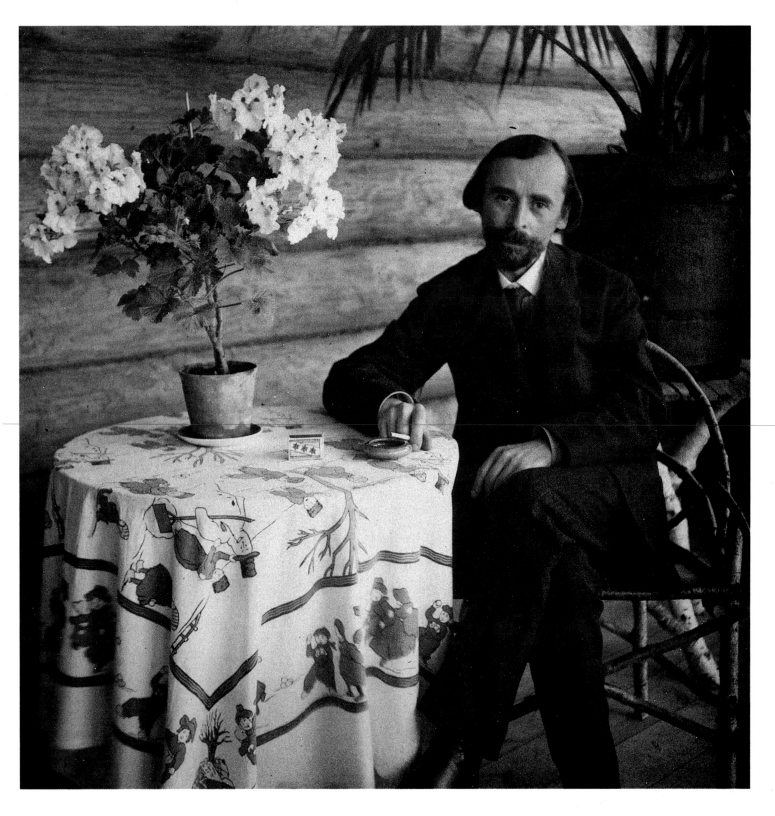

31 'BELOUSOV'. It was in a letter to his old friend, the poet and translator Ivan Belousov, that Andreyev wrote: 'If I were Tsar, I'd make everyone take up photography.' In his memoirs Belousov recalled this photograph being taken at Vammelsuu. The table-cloth was probably bought by Andreyev on his trip to Holland in the summer of 1909.

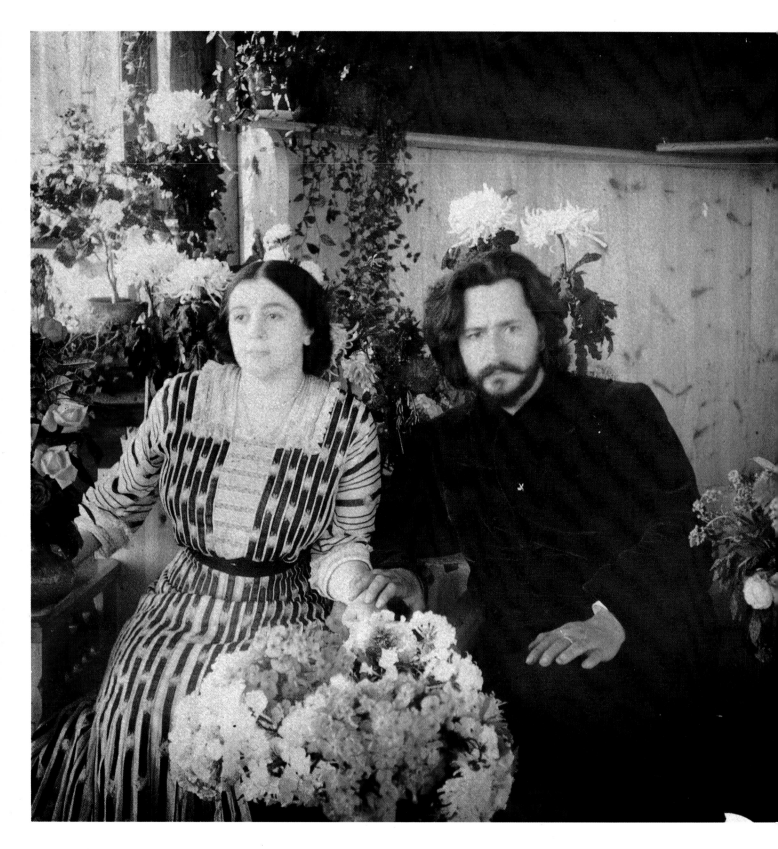

32 ANDREYEV AND ANNA in a flower-bedecked room of the Vammelsuu house.

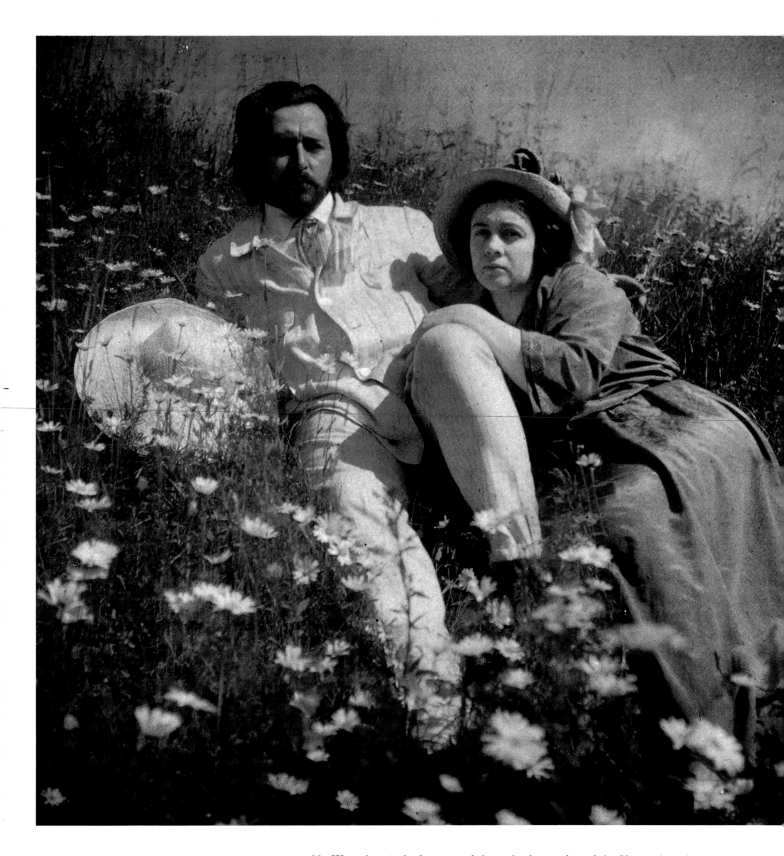

33 'WITH ANNA'. Andreyev and Anna in the garden of the Vammelsuu house.

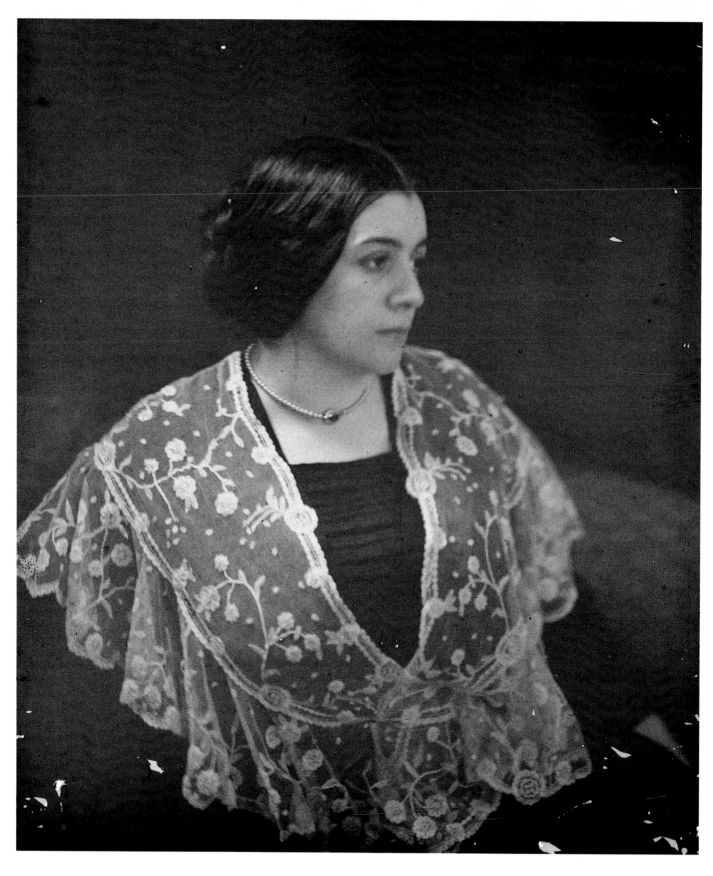

34 ANNA Andreyeva wearing a lace shawl.

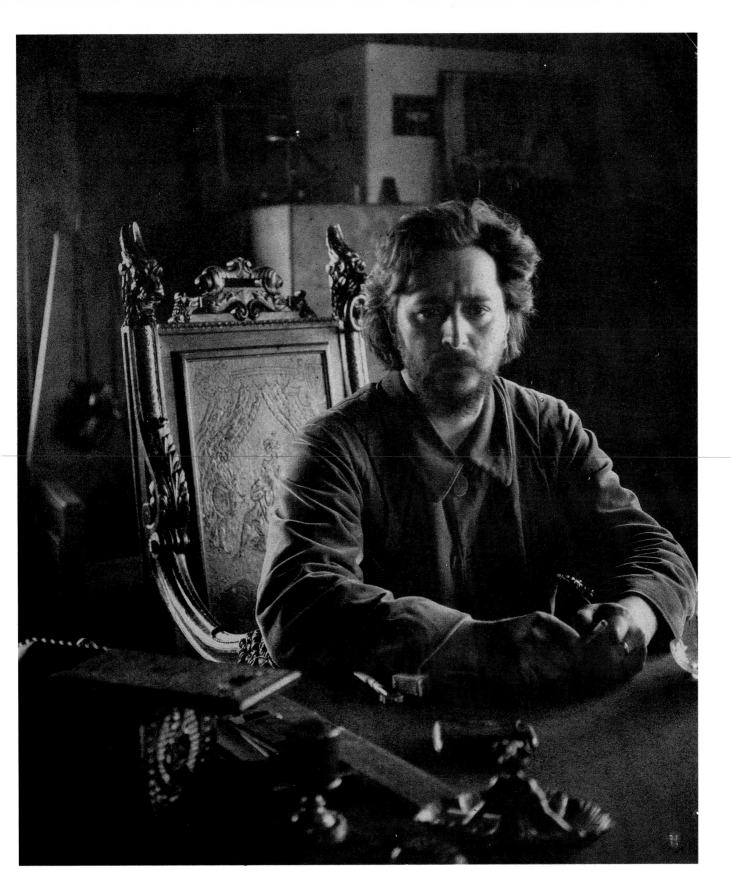

35 'Leonid at his desk, mid-May 1910'. The elaborately carved chair has survived and is part of the display in the museum in Andreyev's home town of Orel.

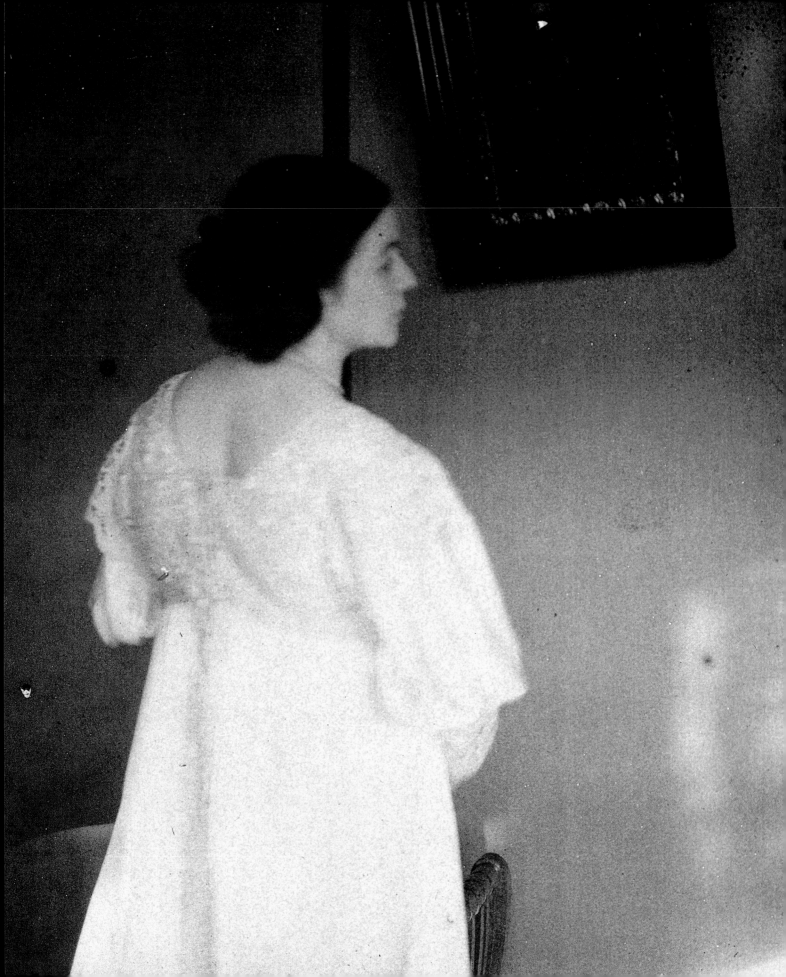

36 ANNA Andreyeva was the inspiration for many beautiful portraits, some conventional in pose and composition, others experimental, particularly where unusual lighting effects could be achieved.

37 'IN BED, ASLEEP'. Savva, Andreyev's first son by Anna, was born in 1909 and his god-father was the great singer Fedor Shalyapin (Chaliapine). Savva was Andreyev and Anna's open favourite, accompanying them on their journey to Italy in 1914, for instance. After the family emigrated, he became a ballet dancer and teacher and died in Buenos Aires in 1970.

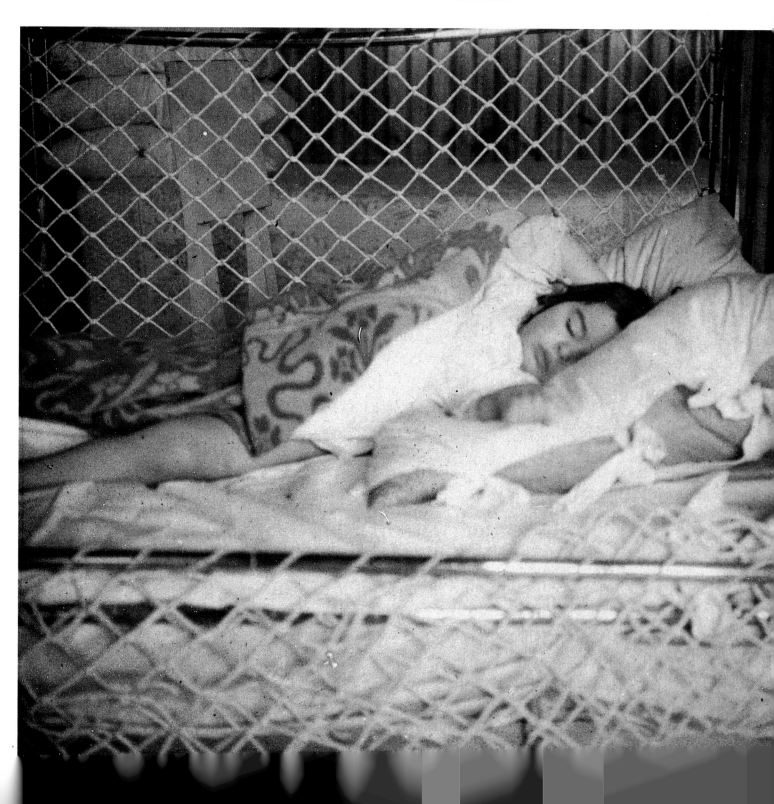

38 'THE STUDY IN KOIVISTO'. A general view of the room in the summer home in which plate 1 was taken.

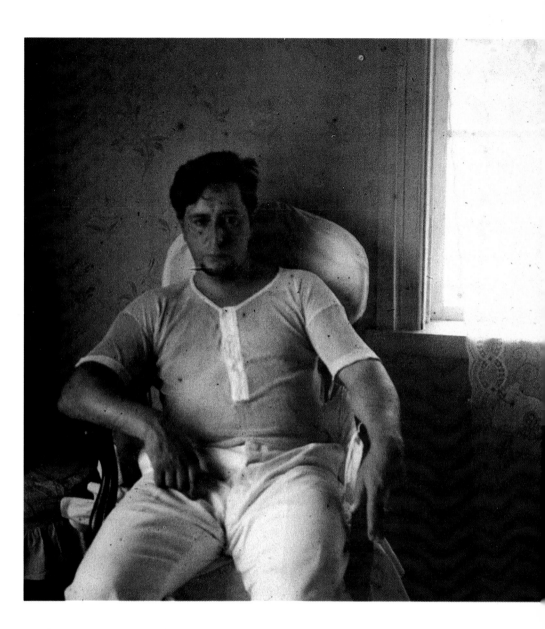

39 'LEONID AS A HINDU'. Andreyev usually shaved off most of his beard and cut his hair short for the sailing season. He is seen here in the house on the island of Koivisto he took for the summer of 1913.

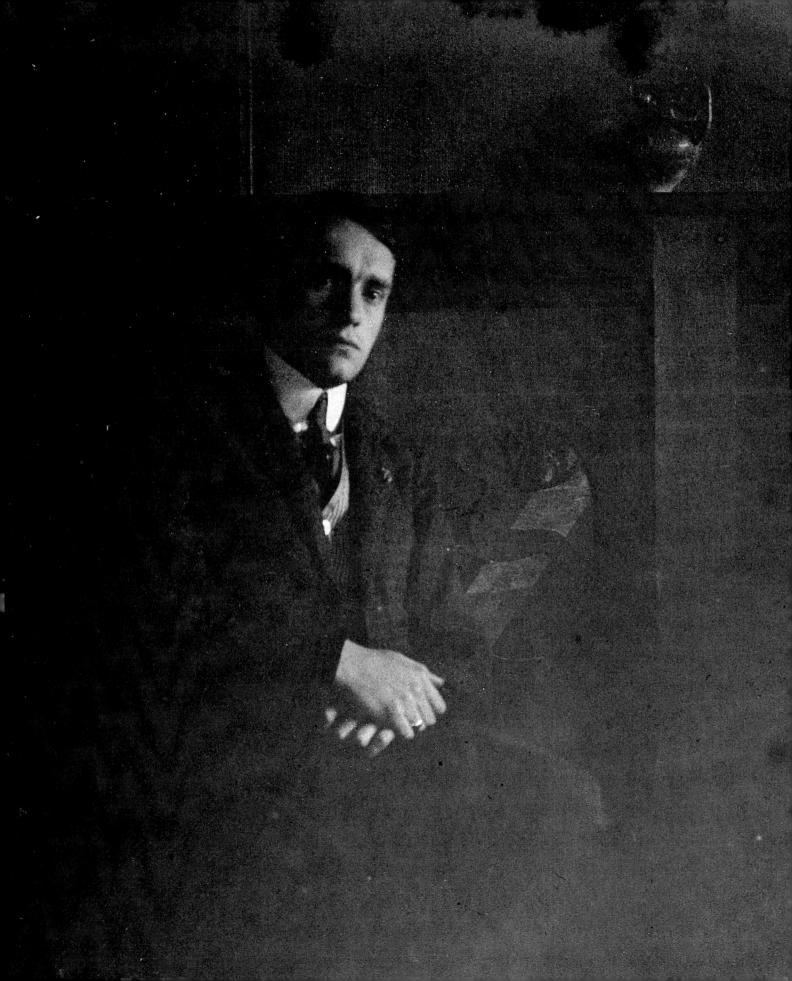

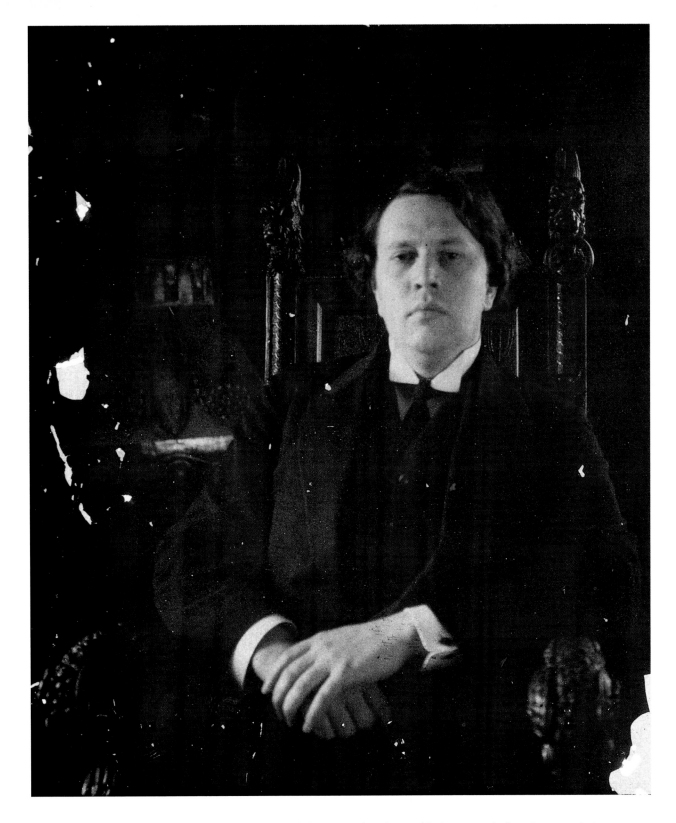

40 'ANDREICH, mid-May 1910'. Andrei Ol was the architect of the Vammelsuu house, his first commission after completing his training with Saarinen in Helsingfors (Helsinki). In 1908 Ol married Andreyev's sister, Rimma. He became a prominent Soviet architect and died in Leningrad in 1958.

41 'A. N. TOLSTOY'. Aleksei Tolstoy was a talented young writer whose career blossomed in the Soviet period, when he wrote mainly historical novels. Here he is seated in Andreyev's chair in the study of the Vammelsuu house.

42 'CHUKOVSKY. Late May 1910'. Kornei Chukovsky was one of pre-revolutionary Russia's most brilliant literary critics and journalists. He lived not far from Vammelsuu and frequently visited Andreyev, of whom he left a penetrating and sympathetic memoir (see p. 21–24). After 1917 Chukovsky became one of Soviet Russia's best-loved children's writers, as well as being a leading translator and scholarly editor.

43 'I. E. REPIN, late May 1910'. Repin was perhaps the greatest of the Russian realist artists. He painted several portraits of Andreyev and Anna Andreyeva and was a close friend of the Andreyev family. He is seen here in the studio of his home 'Penates' in the village of Kuokkala, a few miles from Vammelsuu.

Opposite:
44 'YASINSKY'. Ieronim Yasinsky was a colourful literary critic who wrote one of the first articles on Andreyev's stories in 1901. Andreyev always remained grateful to Yasinsky for his early support. He is pictured here in the same setting and possibly during the same visit as Aleksei Tolstoy (plate 41).

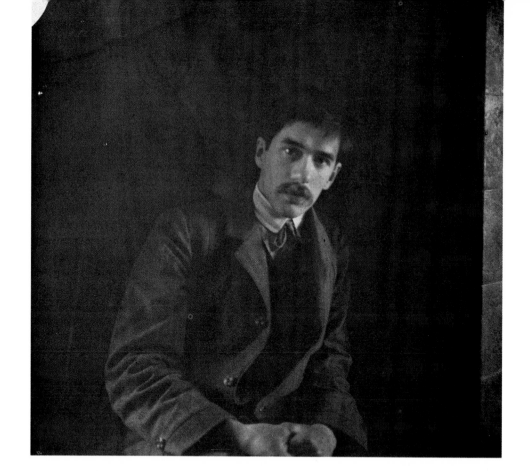

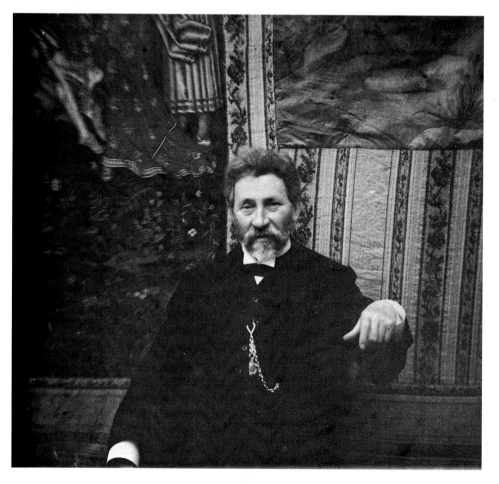

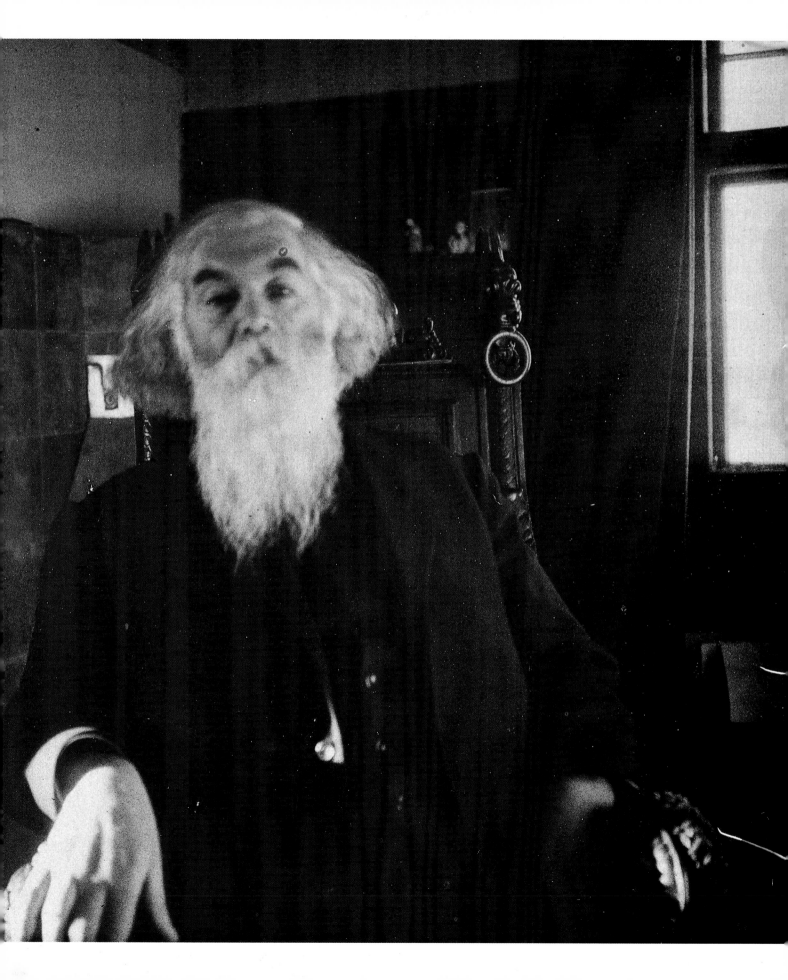

Opposite:
45. Anastasiya Andreyeva looking out of a window at Vammelsuu. Andreyev's mother was utterly devoted to him, and his letters to her during the brief periods when they were apart testify to his great tenderness for her, as well as revealing his lively sense of humour and fun. Anastasiya tried to commit suicide when Andreyev died and never recovered from the blow of his death, dying herself the following year.

46 Savva and Vera Andreyeva possibly in the garden of the house Andreyev rented on the island of Koivisto for the summer of 1913. Like her half-brother, Vadim, Vera, who died in Moscow in 1986, wrote fascinating memoirs of her childhood under the title *The House on the Black River*.

47 'In his pram'. Savva Andreyev as a baby in the garden of the Vammelsuu house. Andreyev never tired of photographing Savva and left hundreds of fine pictures of him taken at home and abroad.

III Artist of nature

48 'ACROSS THE MEADOW'. One of Andreyev's many
studies of the countryside around Vammelsuu.

I fear the city, I love the empty sea and the forest. My soul is soft and impressionable; and it always assumes the shape of the place where it is living, the shape of the things it hears and sees. So it either becomes big, spacious and bright, like the evening sky over the empty sea, or it shrinks to a tiny lump, turns into a little cube, or stretches out like a grey corridor between blind stone walls.

These opening words by the anguished narrator of *The Curse of the Beast* (1907), the story through which Andreyev attempted to exorcize the cripplingly painful memory of his wife Aleksandra's death in Berlin, also reflect his own acute sensitivity to his surroundings and in particular to nature. In a letter to the critic Lvov-Rogachevsky in early 1908 Andreyev explained his imminent move to the new house at Vammelsuu in the same terms of the conflict between city and nature:

This spring I shall be settling permanently in Finland, for both the summer and the winter. My purpose is to get closer to nature, which I love endlessly, and to find more suitable conditions for work than I have in town. Let me say a little more about nature. It is the first book I read and the only one I can always read without getting bored. I still cannot determine just how important nature is to me.

Practising on the tightly-stretched wire which is my life and my literature, I would already have broken my neck at least twenty times, if I had not had as my balance – nature. It and it alone restores my lost equilibrium. It is an inexhaustible source of joy and spiritual health for me. It is what gives me the as yet vague, but firm conviction that one day I shall succeed in discovering the strength-giving source of life and shall understand why life is joy and not sorrow.

Andreyev here seems to attribute to nature a vital role as a balance against both the life he led and his literary work, and it is certainly true that few of his readers would immediately associate Andreyev with such a profound love of nature. This apparent contradiction between the man and the artist was something which preoccupied Andreyev himself, and in his diary for 28 April 1918 he reflected on his inability to give adequate literary expression to his love of nature:

Warm rain. Wonderful. Wearing my leather jacket and leather sea-cap I walked in the rain. Wonderful. This is the second day my head has hardly ached at all, and that's worth something, too. . . .

Yes, wonderful. But then, as happened yesterday, my soul will suddenly be stabbed by a sharp sorrow, a violent agitation, almost by a cry of 'Give me it!' That was when I remembered the skerries and [my boat] *Distant One*. Within this whore called Leonid Andreyev, who used to confess in the public square in front of a stenographer and a policeman, there is a whole terra incognita, an enormous expanse of the most profound and treasured inner experiences. The sea and my love of it . . . the most genuine, authentic, tender love, a long affair with a mistress, striving and languor, sadness and despair, moments of great joy and almost sensual rapture.

Everything I experienced in my youth during periods of wild infatuation with women I now feel towards the sea. I remember how the spring before last, when the sea was closed to sailing because of the war, I went through some strange days here: I sailed on *maps* of the sea, and that phantom sailing, that protracted dream was my true reality; I was only vaguely aware of my surroundings and barely took anything in.

The sea!

When I was still a small boy back in desperately waterless and dusty Orel ... I felt the great pull of the sea. And just as for believers the word 'God' is probably inscribed with some special signs or other, so also for me the word 'SEA' was written and spoken in a special way. The word alone, even if it cropped up by chance, would fill the whole page and tower over the rest of the text like Cologne cathedral over the buildings around it.

And there's the rub. Why don't I, why can't I write about the sea? I want to – but I can't. You'd have thought I was already a 'master craftsman'; and occasionally I do sense my power fully and strongly. But for the sea – I have neither words nor colours, nor the ability to work at them, i.e. painstakingly and persistently to pull out the spillikin-words and carefully build palaces in the sky from them. I want to be able to encapsulate the sea in one word, one breath and sound. How easy it is to describe someone else's mistress and how hard to describe your own!

And this impossibility of writing about the sea – is one of the things I suffer from constantly. The whore kisses everyone, but for her lover her lips turn to stone and her tongue is dumb. Of course, I have tried, but the result is cheap rubbish and vile rhetoric, rhetoric born of my rapture; because all words are too small and insignificant I end up writing a lot of nonsense with them. I sense that some special form has to be found . . . some special form . . .

The sea is only part of what I *cannot* write about. I cannot write about *nature* or about my *love*. To judge by the small amount of landscape description in my works and its auxiliary function, the false conclusion could be drawn that 'nature' occupies the usual semi-auxiliary place in my Weltanschauung that it generally occupies for all normal people. Who doesn't love 'nature'? – any idiot in white shoes loves it, any pink parasol says the same.

The thought that his attitude to nature might be confused with that of ordinary mortals had evidently troubled Andreyev for some time, for Vadim Andreyev recalled his father telling him on a train-journey to Petrograd during the First World War:

'Everyone talks about their love of nature. Any dacha-dweller in white trousers will maintain that there is nothing in the world to compete with nature. I remember seeing someone like that sitting on the sea-shore reading a book. It was sunset, one of the most beautiful sunsets that you could get on the shores of the Gulf of Finland – and he was reading. In the sky the clouds were engaged in a monumental battle, crashing into one another, changing their shapes and colours every minute, dying and coming back to life again, lit by a sunray which would unexpectedly break through them – and he carried on reading. When it grew dark and the sky

turned grey, and only the sea, which had suddenly grown cold and become transparent and smooth, continued to reflect the play of colours of the rainbows in the sky, by now invisible to the eye – he continued reading, his nose buried in his book. Yet he, too, would maintain that he loved nature.'

It clearly never occurred to Andreyev that the most eloquent evidence for his exquisitely highly-developed sensitivity to natural beauty might lie in his photographs. Yet looking at them now we cannot fail to respond to their compositional brilliance and atmospheric power. Even the most accomplished word-painter could not match what Chukovsky called their 'elegaic musicality'.

Andreyev should, however, by no means be thought to have totally failed to convey his love of nature in his literary works. As the extracts below demonstrate, he was capable of creating vivid word-pictures, several of which could indeed serve as captions to his photographs. He was nevertheless undoubtedly right to describe landscape description as having an 'auxiliary function' in his works, although it is hard to see what independent function he felt it could convincingly serve within the restricted framework of the short story.

In the Spring, an autobiographical story published in 1902, describes the effect of spring on Pavel, a schoolboy who has been shocked out of his thoughts of suicide by his father's death:

The earth was creating. The green leaves, downy and smooth, broad and pointed, were already so dense that you could not see through them. They were all so young and joyful, full of mighty strength and life. It almost seemed possible to see them growing and breathing, to see the grass reaching out to the sun from the moist, warm earth. And everything in the garden reverberated with a deep hum, full of concern and passionate joy for life. It came from both above and below; whoever was humming and singing could not be seen, and it seemed to be the grass and flowers and the high blue sky singing. It seemed possible to hear the grass and smell the fragrant, sultry buzzing, so inextricably had everything, smell, sound and colour, merged into a single wonderful harmony of creation and life.

In one corner, Pavel saw the sunlit silver birch which he had watched his father plant. He remembered the black, turned earth and the tree standing in it, and now there the birch was, slim and tall, easily, effortlessly spreading through the air its heart-shaped leaves, which were coloured a tender, young green. And Pavel felt sorry for his father, and the slim silver birch suddenly became close and dear to him, as if in it the spirit of the man who had given it this merry, green life had not yet died, nor would ever die.

Spring plays a similar part in *Youth* (1899), where another schoolboy is struck by the contrast between the natural world and his school, the scene of a shameful beating he has administered to a classmate:

The sun was dazzling as Sharygin returned home. On the poorly swept pavements of the little provincial town there were puddles of melted snow, which reflected the lamp-posts and the

blue abyss of the cloudless sky beneath them. Spring was fast approaching, and the sharp, fresh air, which smelled of thawing snow and distant fields, cleared the classroom dust from his lungs. How dark and oppressive that classroom now seemed! What had happened in the classroom an hour earlier also seemed an oppressive and heavy dream, for it could not have happened here, where the sun shone so joyfully and the sparrows, driven half crazy by the spring air, chirped with such skittish merriment.

Such use of nature description at psychological turning-points was quite common in Andreyev's early stories, and he sometimes included quite elaborate descriptive passages in his newspaper articles as a prelude to the reflections on Russian society to which they were for the most part devoted. This example is taken from a 1901 article later given the title 'People who walk on the shady side':

Have you ever noticed how the sun shines in April? Its light does not spread through the air, like sunlight in the summer, when the whole blue sky is transformed into a goldspun cloak and it is painful for your dazzled eyes to look at it. Nor is the April sun like the melancholy autumn sun, whose gentle farewell smile harmonizes so sadly with the pale azure and the elegaic tints of the dying leaves. It is also quite unlike the dull crimson December sun, casting blood-red patches, as it sets, through frozen window-panes onto white walls, cold, gloomy, hurrying to escape from the frozen plains of the north.

In April the sun rises above a clear horizon, like a handsome young warrior dressed in flashing armour, and its rays are like fiery arrows. You need no imagination to see them against the calm sky and to follow their path down to the earth. The sun divides the street into two halves: on one side, in the shade, everything is yellow, dark and stone-hard after the night's frost, while on the other, struck by the arrows, everything is bright, festive and soft. And completely different people walk on each side, and I hate the people who walk on the shady side on a sunny April day.

In his later prose works Andreyev succeeded in combining the use of nature description as part of the protagonists' psychological development with the creation of memorable extended mood pictures. The first of the examples below comes from the novel *Sashka Zhegulev* (1911), while the eery story *He* (1913) furnishes the two winter scenes that follow:

Tomorrow the cold, dark-blue storm-clouds would sail across the sky, and between them and the earth it would become as dark as it does at dusk; tomorrow the cruel wind would come from the north and scatter the leaves from the trees, turn the earth to stone, make it as colourless as grey clay, squeezing all colours out and killing them with its cold. Bent double and shivering with cold, both men and the brittle blades of dried grass, both the crowns of trees and faded, dead flowers in the meadows, would turn their backs to the wind and look south with their lifeless faces.... The trunks and branches of trees would emit long, doleful creaks, and at the

open edge of the forest a dry, curled up oak-leaf would rustle mournfully, as it prepared to hang on to its useless life for the whole long winter until the new spring arrived. . . . Chased by the wind, occasional snow-flakes would whirl in the dark sky, but would fly past without landing on the earth

But today it is quiet, fearless and majestic in the tall forest, like in a church among the golden iconostases and countless altars. The ancient trunks rise like columns, and their translucent leaves shine with an inner light: the lower leaves of the hand-shaped, fretted maple look like the burning green glass of icon-lamps, while their crowns are all liquid gold and crimson. The gold flows down to the ground, and radiant halos circle round the feet of the large trees, while the little saplings and bushes, as the forest's children, have already shaken themselves half free of the heavy gold and stand up straight and slender.

●

Of course, I should have left, and all the arguments of my reason were for leaving in a hurry, even immediately, that same day, the very minute that the idea of escape occurred to me. But something much stronger than reason with its boring and dull voice chained me down, directed my will and led me deeper and deeper into the circle of mysterious and gloomy experiences: sorrow and fear have their fascination, and great is the power of the dark forces over the lonely soul which has known no joy. I do not know whether that is what I thought at the time, or whether I found some other false excuses, but anyway I rejected the idea of leaving almost without hesitation and remained to face fresh sufferings.

It is possible that I was held back partly by the arrival of some wonderfully fine days, full of sunshine and peace. The frozen mists at night covered the trees with hoar-frost and transformed the telegraph wires and every tiny twig into a shaggy white branch of some previously unknown beautiful plant. The garden, which had grown bare in the autumn, once more became impenetrable, as if covered by new, white, foliage; and the shadows on the branches were so faint that distant and nearby trees completely merged, all their branches became intertwined, and it seemed as if your dazzled eyes would never distinguish anything in this motionless, frozen, silvery confusion. But if you looked again, everything suddenly stood out, every twig swam in a sea of blue sky, and there was as much air between the thick, white, fluffy branches as there was in the whole wide world. It was wonderful and unusual, and when the sun's yellowish-pink rays also joined in the motionless game, gently fading and flaring up and disappearing again somewhere in the most distant flickerings of the hoar-frost, the beauty of it was almost painful for your eyes and soul.

●

I went out in just my frock-coat, without a cap, but I did not feel the cold, besides it was not a particularly frosty day, otherwise I should have frozen, of course. I did not go towards the road, but skirted the garden with its deep snow and made my way onto the shore and struck out over the sea. For some reason the snow on the ice was not so deep, walking was easy, and soon I was already a long way from the shore, in the middle of a deserted, flat, white expanse. I had stopped crying, was not thinking about anything and just walked on, seeming to dissolve with

each step into the emptiness of the white, boundless surface. In front of me and around me there was neither a track, nor a footprint, nor a dark spot; and when I began to tire and to feel the cold and stopped for a moment and looked around – everywhere there was the same deserted, flat, white expanse, almost pure emptiness itself as is only seen in dreams. And soon my advance took on all the features of a long, monotonous dream, of a resigned and hopeless struggle with insuperable space. . . . From time to time the layer of snow grew thicker, my feet sank into deep drifts, and I stopped, looked around for a moment and said:

'Such grief! Such sorrow!'

As the passage from Andreyev's diary quoted above clearly indicates, it was above all the sea that preoccupied him. In another of his 1901 newspaper articles he tried to explain the emotions aroused in him by the sight of the Baltic Sea outside Riga:

The sea . . .

I had waited patiently and for a long time. I do not know why we, the inhabitants of dry lands, dispatched by our fate and birth into the heart of continents, are always so eager to seek the sea, and even before we have seen it, love it like an old friend from the beginning of time. This love originates in the dark depths of antiquity and flows in our Varangian blood as a vague striving – this agonizing and sweet love for the infinite, the unknowable, the eternally vital and the enigmatic. Every time I look upon the sea, I am overcome by trembling, and I feel an urge to do something that would express both my fear and my rapture and my adoration, fall to my knees, kiss it and quietly ask it for something. It is as if a curtain rises before me and I see that which it is not given to man to see, and that is why I feel so awestruck and happy.

In a newspaper interview in 1913 Andreyev said that he did not love the sea platonically, as did many people, but actively, conducting a battle with it, and he continued:

I fell in love with the sea a long time ago, when still a child, through the books I read. And I was waiting for it. And I have never experienced such joy as when I first stepped onto a deck which moved under my feet. I felt that something was being fulfilled which *had to be fulfilled*.

I may forget everything, I may stop loving everything, but I shall not forget or stop loving one thing, and I shall go to the next world with sadness, with the memory of the thing I could not grasp, could not gain control of, the thing I perhaps failed to merge with, did not exploit and absorb as profoundly as I wished – a sandy beach with a wave breaking on it. What is it about that wave? What? . . . I do not know. But there it rolls in, raises its crest and . . . ah! – it inhales, blows salty spray in your face, disintegrates and seems to die. But then again: something rolls in, inhales and either falls back, or again dies . . . Was it the same one? No. Another one, then? No, not another one, either . . . And I do not know any source of pleasure more inexhaustible than these sighs of the salt sea, than this cosmic rhythm of the sea. That contains for me all the fascination and depth and joy and pain of existence. . . .

An uncompleted article written during the First World War gives us perhaps the best impression of the passionate relationship Andreyev enjoyed with the sea and particularly the Finnish skerries, of which he left so many beautiful photographs:

I entered the life of the skerries slowly and gradually, as one should. Of course, that was not the result of deliberate planning on my part, but it came about through a series of lucky chances, which limited my dominion over the seas during my first summer to a pathetically small rowing boat and a pair of oars. I was living at the time beyond Helsingfors in the beautiful Esbo skerries, and almost every day I used to row six miles or more, wandering from island to island.

•

And I made all my boat trips in a state of complete nakedness. To start with I felt ashamed of myself, but I soon got used to it, stopped noticing my nakedness and abandoned myself to sun, wind and water with all the joy of reawakening life. You still feel ashamed while you are white, but once you turn as black as a negro, your skin becomes your natural costume . . .

You dip the oars lazily in the transparent blue-green water. . . . You fall to thinking and stop rowing: let the light swell carry you, after all it does not matter where you float to! Besides you want to cool your hot side and turn the other side to the sun; or you lie down in the bottom of the boat and look up into the high blue sky as if from inside a shell, and you listen to the whispering and singing of the waves against the sides of the boat.

•

Rested, you row on towards the islands; and sometimes you visit five or six of them in a day. They are all uninhabited and require no costume, and to walk naked through their woods, or to leap like the Devil about their cliffs and ravines is a very special, long forgotten joy, which carries you back to the times of your distant and happy ancestors. The whole of you lives, and not just your exhausted brain or the intellectual expression on your face, the whole of you breathes, the whole of you is filled with burning light.

•

The furthest I rowed was to the beautiful and fairly large island of Julholm. Like all but a very few of the islands in the skerries, it was made of solid granite, but over the thousands of years of its existence it had accumulated soil carried by the wind and become thickly overgrown; the gently sloping side facing the mainland bristled with stern spruces, while on the side facing the open sea the cracked and eroded granite was a naked pink and plunged to the sea in broken ledges or went down in smooth steps. And the deep blue sea began immediately below it. . . .

There is no line in nature simpler and clearer than the curved line of the horizon at sea – nor is there a line more magical and spell-binding, which transfixes your eyes and soul like a wand held by a mighty wizard. Like eternal freedom, like endless striving, it draws the human will, restricted by earthly laws, and promises, if action is taken, indescribable bliss. Of all the lines on the earth, including those made by hard-set mountains, buildings and trees, it alone is heavenly and together with the stars and the whole celestial realm sings of infinity.

49　A TYPICAL VIEW of the surroundings of Vammelsuu, showing a country road.

50 THE HOUSE AT VAMMELSUU was one of Andreyev's favourite subjects. Vera Andreyeva wrote that: 'He would endlessly photograph every corner of our house'. Several of his studies were taken at the difficult times of sunrise and sunset. This one is entitled 'Sunset'.

51 THE STABLES at Vammelsuu.

52 'SUNSET'. The Vammelsuu house photographed at sunset in a composition very reminiscent of one of Andreyev's pastel paintings of the house.

Opposite:
53. 'REPAIRS'. The idea of building such an enormous house entirely of wood soon proved ill-advised, and major repairs had to be carried out within a few years of its completion in 1908. The house's fabric rapidly deteriorated when maintenance had to be abandoned after 1917, and Anna Andreyeva sold it for demolition in the 1920s.

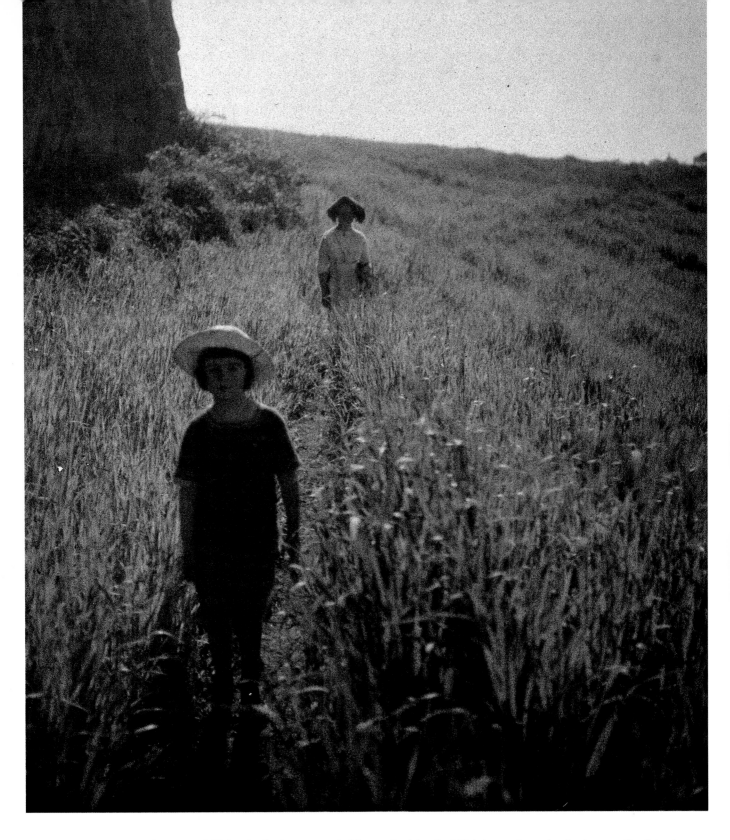

54 'SAVVA, VERA, TINCHIK'. Vera, Savva and Valentin Andreyev, probably on the island of Koivisto, where the Andreyevs lived in the summer of 1913. Valentin was the youngest of Andreyev's children by Anna. He died in France in 1988.

55 'SAVVA in the Campagna'. Savva Andreyev and his nurse, Minna, on one of the many outings to the Roman campagna (see p. 117).

56 'Nikolai on Distant One'. Nikolai Ivanov was Andreyev's mechanic and 'boatswain' on his voyages about the Gulf of Finland and accompanied him on a short journey to Italy in late 1912. He is seen here aboard Andreyev's yacht 'Distant One'. The ship's clock on the right it still owned by the Andreyev family.

57 'Leonid. On the motor-boat'. Andreyev on his first boat, called 'Savva', on the Black River below his house.

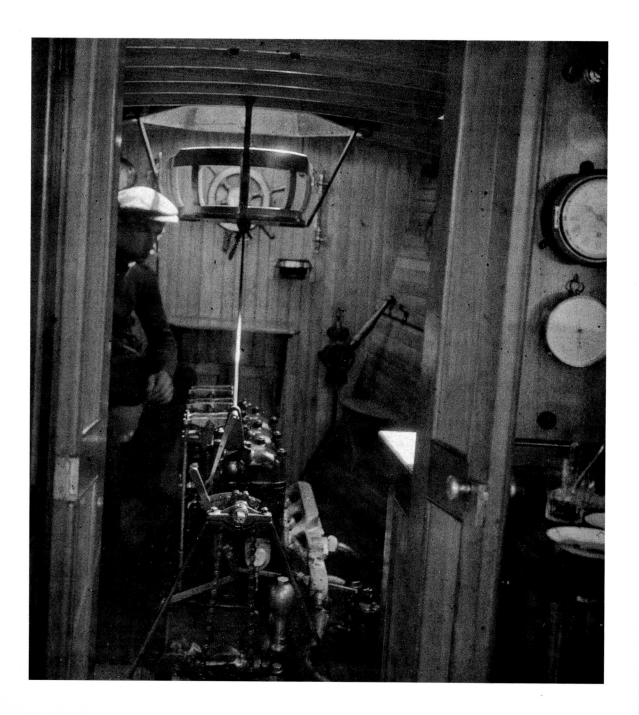

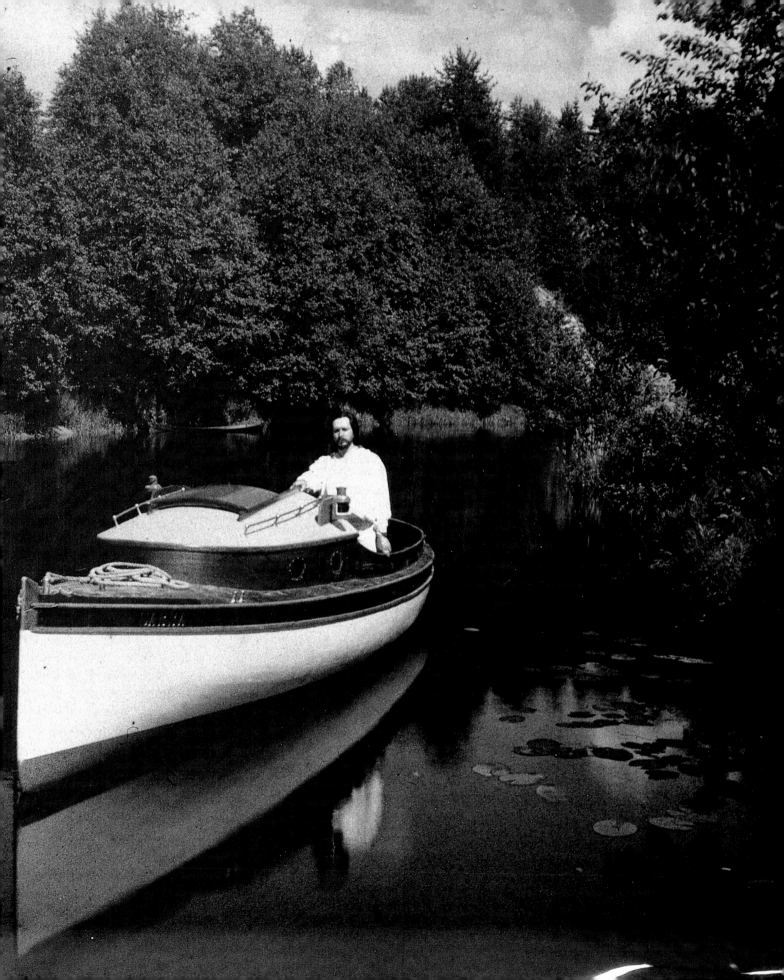

58 'A LAIBA BEING BUILT. KOIVISTO'. Laibas were sailing boats once common on the Baltic and some Russian rivers. This photograph was taken on the island of Koivisto in the summer of 1913.

Opposite:

59 'FISHING NETS'. One of Andreyev's many studies taken on the shore of the Gulf of Finland.

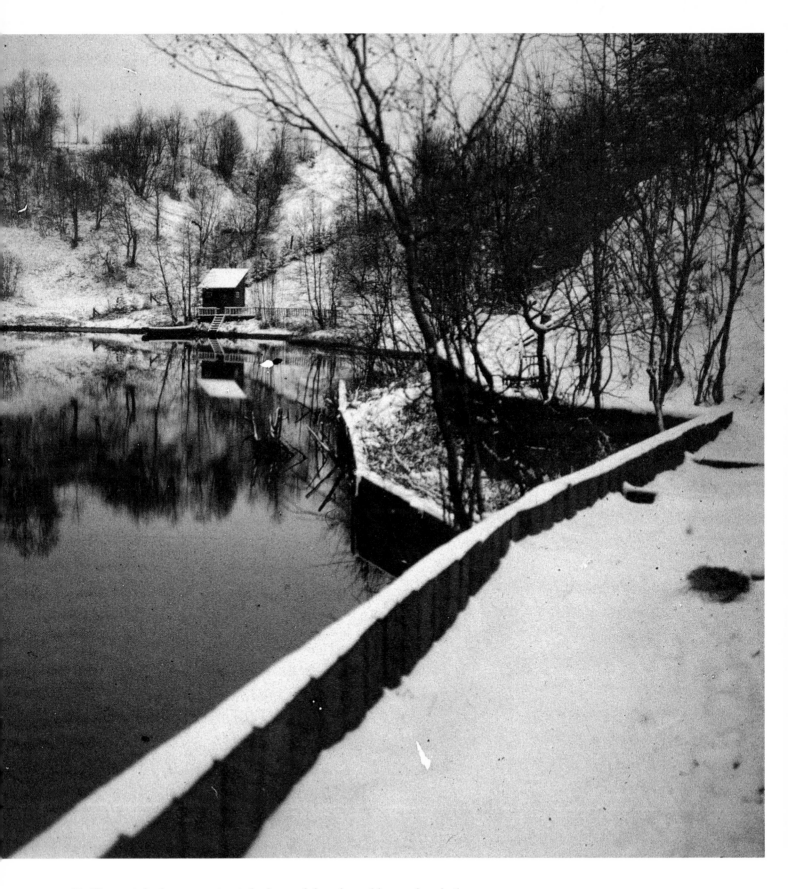

60 'THE DAM'. Andreyev constructed a dam and changing-cabin, seen here in the winter, on the Black River below his house.

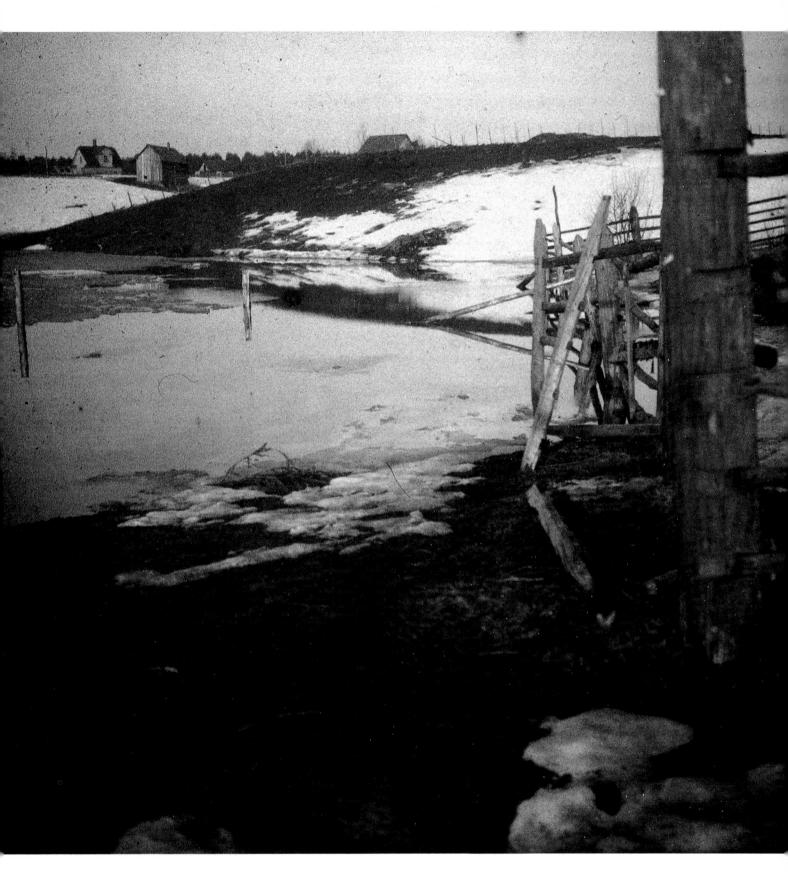

61 'THE BROOK'. The edge of Andreyev's Vammelsuu estate during the spring thaw.

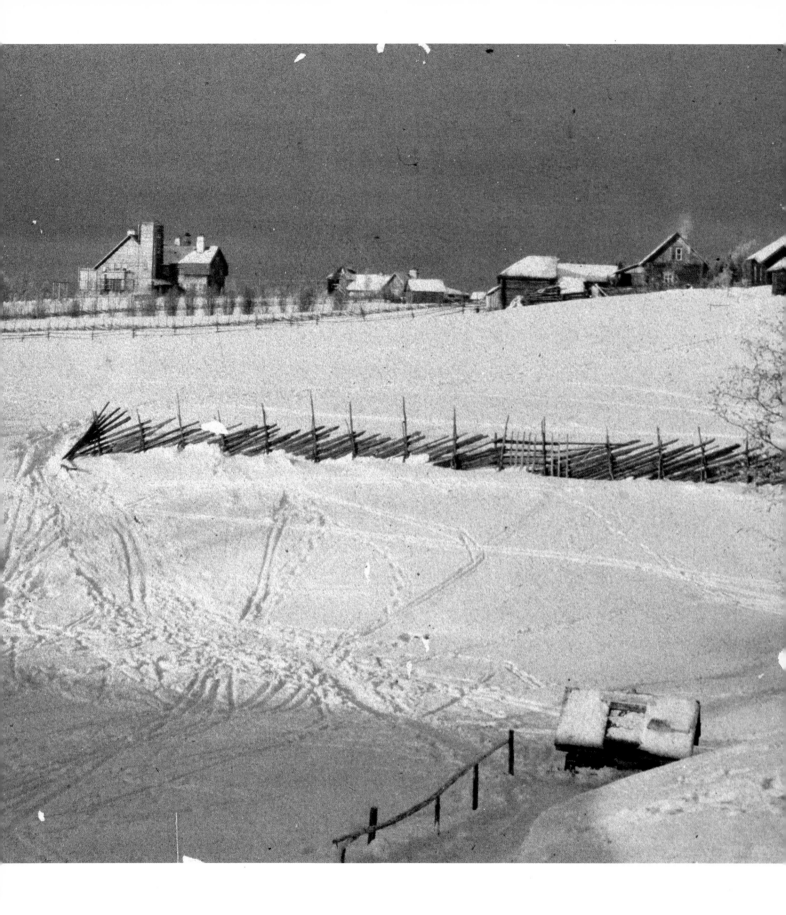

62 'Winter storm-cloud'. There is no obvious sign of the threat Andreyev's title implies in this sun-sparkled snowscape of Vammelsuu village, with Andreyev's house on the left.

63 'Sunshine by the house'. A view of the garden at Vammelsuu in the winter.

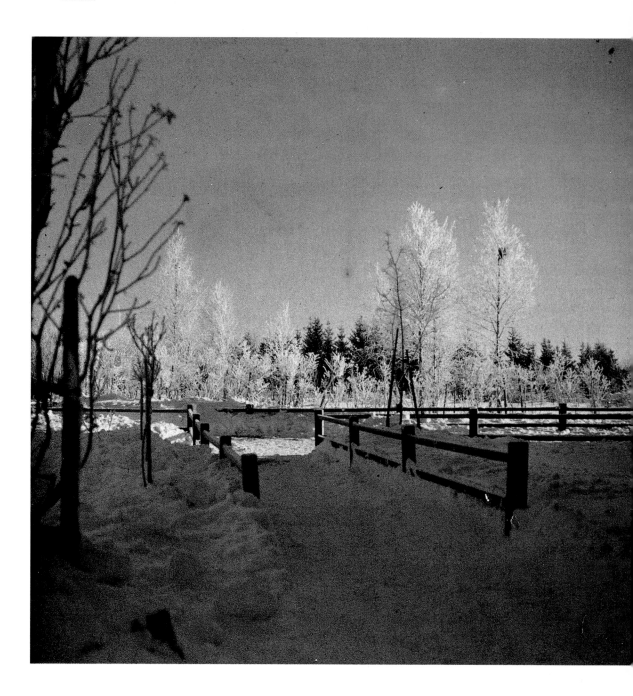

64 'THE GULLY'. 65 'THE LARCH FOREST, two tracks'. Views of the woods near the Vammelsuu house.

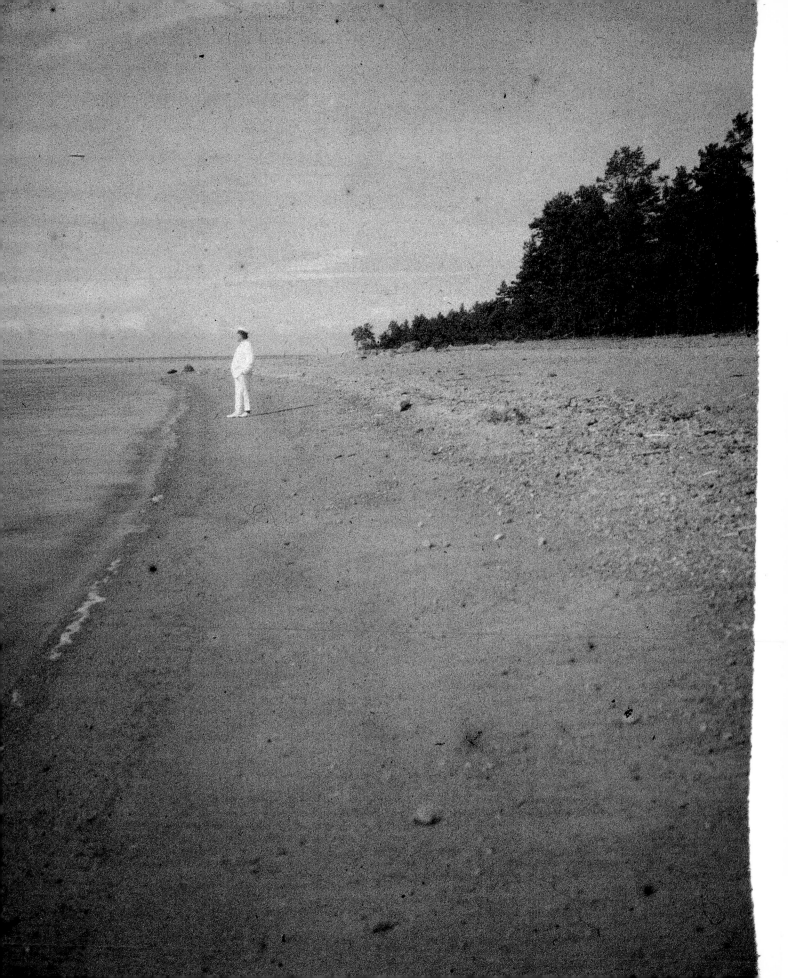

68 ANDREYEV AND SAVVA nude on one of the islands in the skerries during a summer sailing expedition.

69 ANNA Andreyeva and an unidentified lady guest looking over a cliff on an island in the skerries.

Overleaf:
70 'DISTANT ONE BY BJÖRKÖ ISLAND'. Andreyev's yacht 'Distant One' moored at the small island of Björkö near Helsingfors (Helsinki).

71 'WINTER ON THE SEA'. Savva Andreyev and his nurse photographed on the ice of the frozen Gulf of Finland. The domes of the island fortress of Kronstadt can be seen in the background on the left. The columns of ice on the right are formed naturally through the pressure of the expanding ice layer. Andreyev left his signature in the near right-hand corner.

IV A Russian abroad

72 'AUTUMN TRACK'. One of four photographs of the same stretch of mud track outside the Vammelsuu estate that Andreyev took at each of the four seasons.

Andreyev's first contact with Italy and the Mediterranean in 1907 was associated with the aftermath of Aleksandra's death and his own nervous breakdown, and even the beauty of Capri seems not to have made much of an impact on him at the time. Yet he came to love Italy deeply and visited it three times between 1910 and 1914, taking dozens of fine photographs of the cities he stayed in and the landscapes he passed through. During each journey he wrote almost daily letters home, mostly jolly and full of family jokes and showing Andreyev at his 'Moscow student' best, as Chukovsky recalled him. These letters are of special interest here, for they contain most of the very few references by Andreyev himself to his photography.

In December 1910 Andreyev and Anna travelled by train through Germany and France to Marseilles, from where they took a boat to Italy, calling at Corsica on the way. Andreyev's letters to his mother from Marseilles and Florence give a vivid impression both of his unbuttoned mood and of his great joy at being on the Mediterranean:

Oh, what an effort it is to travel through all these Europes! All my languages have long since become confused and I now look like a fat Tower of Babel. Yesterday we were thrown off the through-train in the middle of the night, and what became of us nobody knows.

At the moment we are in Marseilles. It's spring. The sea is wonderful. We only look at it from the shore, and even then to avoid any danger I hold on to a lamp-post and look with my backside. The town is very beautiful. But we gave Spain a miss – it's too far, and if we keep being thrown off trains you've no idea where we might end up. . . . I keep saying *merci* the whole time. The expression on my face is French with a slight hint of German.

Don't worry, my little mushroom, about my not writing very often – it's quite impossible on a trip like this. You get very tired from running around all day, in the evening you work out your plans for the next day and then get them all wrong in the morning. On top of that their time here is ahead of ours, so every day is five hours shorter. That's some difference: it's morning now where you are and evening here; and things happen in a different order, the French way: day follows immediately after evening, and night comes after lunch, at two in the afternoon English time. It's called *le smoking*.

. . . Tomorrow I'm going to spend the whole day taking photos. We'll be staying here for five days or so, we need the rest.

●

Both in Munich and here we've had excellent, quiet hotel rooms, large and well-lit. At the moment the window is open and the French moon is shining, it looks like ours, only it's green and square. I must say I'm not used to all the racket in towns any more, and at night I keep thinking the trams are running across my stomach.

●

A big kiss for you, little mushroom. Kiss the children for me and give everyone at home my regards. Don't worry about me and don't be miserable, look after yourself. Don't put out to sea in the boat, don't jump from the tower and don't smoke English tobacco.

Our trip has generally turned out very successfully, but the most successful part was our sea-journey from Marseilles to Leghorn calling at Corsica on the way. We left Marseilles at eleven in the morning on Sunday, a lovely and sunny but very windy day. At this time of year you can get continuous fog, but we were lucky. Both the sea itself and the mountainous shore that we sailed along until sunset were extremely beautiful. To start with, it's true, there was a heavy swell and lots of people were throwing up all over the place (Anna restrained herself, but lay in our cabin groaning all the way to Corsica), but by nightfall the wind had started blowing from behind us and the swell died down. The waves were huge and I watched them in the moonlight and went wild with delight. I slept well that night and at sunrise the next morning we arrived at Bastia (on Corsica), where we stopped for twenty-four hours. Such beauty and such warmth, with the sun as hot as in spring. We spent the whole day walking about and I felt completely relaxed. Peace and quiet, mountains, cypresses. . . . We set sail at eight in the morning – and, Mamochka, you can't imagine anything more beautiful. The sea was like a mirror and light blue, the lovely sun shone warmly on us, the stillness – nothing could ever compare with it. And we went past the most beautiful places: Elba (where Napoleon was locked up), Capraia, Gorgona – and at last out of the sparkling azure sea emerged Italy, pink, hazy, golden, covered in villas and gardens. And to the left, high above the blue haze, rose the snowy peaks of the Alps. I have made quite a few sea-journeys in my time, but never before have I seen anywhere more beautiful than that. . . . We reached Leghorn at about three in the afternoon and went straight on to Florence by train, arriving around eight.

And, brother, isn't Florence just an amazing city. It's so beautiful that it almost beats Rome, come to think of it it's even better. Needless to say we're on our feet the whole time and the soles of my shoes have developed corns. . . .

I honestly have no time to write. First and foremost comes photography – and you know what that means.

Andreyev's next visit to Italy was a short trip he made with his handiman and boatswain, Nikolai Ivanov, in December 1912 – January 1913. The main purpose of the journey, although one Andreyev evidently did not particularly relish, was to meet Gorky again for the first time since their break in 1908. Andreyev enclosed a rose picked in the Forum with the letter he wrote to Anna from Rome, and it survives, dark brown and brittle with age, among his letters:

My darling child, I've fallen in love with Italy. Hard to believe, but true. It began while I was still in Venice, but here in Rome it's turning into passion. It's as if I'm seeing everything with fresh eyes, and everything is so wonderful – even the people. Even the people! Well, perhaps not exactly wonderful, but pretty good anyway, and as for the Roman women . . . where do they get so many beautiful faces from? And such very beautiful ones, too! And how diligently unfaithful I am being to you as I promiscuously increase my imaginary seraglio!

Listen: we welcomed the New Year in an Italian train on the way to Florence by drinking a fiasco of chianti and eating some salami. We drank toasts and cursed your cold weather. . . . At

four in the morning we were driving through deserted streets in the thickest fog imaginable (like last time); we arrived at the square in front of our 'New York', with the same bridge and wet tram rails. But everything was deserted and silent. No answer to our knocks, no lights. We stand there thinking; the cabby thinks, too; and suddenly an old man calls out from the middle of the square:

'Tutti mortui!'

It turned out that the hotel had closed, and we went on to another one instead. But that 'tutti mortui', at night, in the fog, spoken by an old man, sounded so unusual that I'll never forget it.

●

But Rome! This must be the fourth time I've been in Rome, but it's only now that I've felt its beauty. I can't write about it, I'll tell you instead. I keep thinking how to arrange for us to *live* here together for a while.

The day after tomorrow we are going to Capri; I shall try to avoid Naples and stop there on the way back. I must admit the thought of talking to Gorky troubles me . . . how boring! I'll have to talk about things I ran away from and have taken such delight in forgetting. But there's nothing I can do now, I'll just have to try to keep our conversation short.

Andreyev's wish to spend longer in Italy with Anna was fulfilled the following year, when they took Savva (referred to in the letters as Sapka and Savka, or Savvka, just as Anna becomes Anichka) and his nurse, Minna, with them to Venice and Rome from February to May. Again, Andreyev's letters to his mother are merry and joyful:

I'm writing to you again from Venice, as we've stayed on here. Everything is going well: our rooms are excellent, we can see half of Venice from our balconies, down below it bubbles with life all day, with a crowd of jolly people moving along and huge ocean liners coming and going. Yesterday a battleship moored right in front of our windows, and today an aeroplane flew around it. We are being well fed, and in general things are very pleasant. In the evenings we go to the cinema. The weather hasn't been all that good for the last two days, with sirens and ships' whistles howling constantly in the fog and drizzle, but the sun is shining again today, red sails are drying on the jetties, and we can see into the azure distance again. I've been doing a lot of walking, but so far I've never managed to find my way home first time: instead of streets they have a tangle of corridors, so that the place is more like an enormous strange flat than a town. You go round and round in circles until your legs drop off – and you can't take a cab, because there aren't any.

It's carnaval here the whole time, people walk around with masks on blowing toy whistles, and today Sapka took part as well: he put on a red half-mask and his multi-coloured coat, blew his whistle and attracted a lot of attention. . . . Anna and I went to the Lido today. There's an

excellent beach there and tomorrow we're going back with Savka for the whole day, so that he can run about on the sand and collect shells. It's good here, Matochka, and the people are nice: no fights or arguments, nobody disgustingly drunk, although everyone has had a drink or two.

We went out of town to the Via Appia today, but the wind was so strong and there was so much dust from the cars that Anichka sneezed all her innards out and we couldn't see anything, so when it started to rain we came back and went to a restaurant. . . . While we were eating, the sun came out and it turned into a warm, pleasant day; we wandered among the ruins of the Palatine until six in the evening, taking photos and arguing, enjoying nature and our mutual love. To tell the truth, the shots Anna took weren't bad at all: if it weren't for her tendency to take nothing but soldiers. . . .

Yesterday was an utterly divine day. I went off for the day several miles into the Campagna, and the sun, the distant views, the huge expanses, and just breathing and looking about me were so wonderful that it all felt like a dream. There wasn't even the tiniest cloud in the sky and a hot-air balloon floated slowly across the dark-blue above me. It was hot. The far-off Alban Hills with their snowy peaks encircled the horizon, and little towns and village stood out like white nests on their slopes. And the green hills rose and fell like waves, with the white road weaving its way between them, and every so often a solitary house showing like a speck of dust and a couple of Italian pines sticking up. I sat down in the grass at the edge of the road and had a marvellous picnic of the food I'd taken with me. I returned home, ate . . . and set out for the Campagna again before sunset; and again it was exceptionally good. There is something that reminds me of the fields around Orel in the footpaths worn into the green knolls; the air, too, is soft, calm and warm, like it is back home on a calm summer's evening outside Orel – and as I strolled along I felt as if I was no more than eighteen and still at school in Orel, rather than the son of such a famous mother.

We went out into the Campagna to the Via Appia, taking the train out and walking back into town along the road. Anna was lugging a bag with our food, and I had three cameras, a library of guidebooks, various dictionaries and everything else to carry. . . . When Anichka takes photos she gets very nervous – she moans, suddenly comes over all weak and rolls her eyes so far they end up half way down her back. . . .

We spent the whole evening developing what we had taken during the day – real hard labour; and both of us wail, because nothing turns out the way it should; Anichka's are all over- or underexposed, and she rolls her eyes again and makes herself look consumptive.

I went in Anichka's company into the Campagna and for campany [sic!] took with us Savvka and Minna with a bag. Anichka took the photos, and I must say from the depths of my immortal soul that even I did not expect such brilliant results. What are the Himalayas and Sanatogen by comparison with her! When instead of a lovingly executed, fine portrait of me,

which almost gave her consumption, the developed photo showed her *hat* – we thought it was just a trick of nature. But when instead of Minna holding the bag, which was taken for her boyfriend Nikanor, we again saw Anichka's hat – we were surprised. But when instead of a whole horse carrying an unusual load we yet again saw Anichka's hat – we began to get worried, since there was a shot of the whole Campagna still to come. But when instead of a portrait of Savvka, which Anichka had placed all her hopes on, we saw her hat again; when instead of palaces, animals, people and great high mountains we kept on seeing Anichka's *hat* – we lost all patience and begged to be killed, so that we would no longer have to see that damned *hat*. . . .

And what do you think our investigations revealed? As she was taking the photos and looking into the view-finder, this self-same Anichka lowered her broad-brimmed hat so far that she obscured all her subjects with it; and so the camera – which couldn't care less! – proceeded to photograph her *hat*.

A mere four years after these happy months in Italy, in his diary for Easter Day 1918, Andreyev was briefly to recall his photographs of Rome and Venice, only to reject them as a possible distraction from the cold, hunger and depression of his involuntary Finnish exile. Yet it was at this most miserable time of his life that Andreyev also produced his most eloquent tribute to Italy, by setting the bulk of his unfinished masterpiece *Satan's Diary* in Rome at exactly the same time of year as his own last visit. It is touching to reflect that Andreyev sought solace from the privations of the last year of his life, as described so harrowingly in his diary, by transporting himself in his imagination to his beloved Italy. In this extract, Satan, who has taken the form of the American millionaire, Vandergood, and an attendant demon in the shape of Vandergood's factotum, Toppy, are on Capri. Vandergood has fallen in love with Maria, the daughter of a confidence trickster who succeeds in cheating Vandergood of his fortune.

The sea was completely calm. From my high cliff I looked down for a long time at a small schooner motionless in the blue expanse. Its white sails hung slack and it seemed just as happy as I was that day. And again the great peace descended upon me, and the sacred name of *Maria* rang out serene and pure, like a Sunday bell on a distant shore.

Then I lay down on my back in the grass. The good earth warmed my back, and there was so much hot light beyond my closed eyelids that it was if I had plunged my face into the sun itself. Three steps away from me was a precipice, a beetling cliff, a dizzy, sheer wall, and that made my grassy couch seem airy and light, and it was pleasant to breath in the smell of the grass and the Capri spring flowers. It also smelled of Toppy, who was lying next to me: when he gets warm in the sun he begins to smell strongly of fur. . . .

The place where we were lying is called Anacapri and is at the highest point of the little island. The sun had already set when we started back down, and a half-moon was shining, but it was still as warm and quiet, and love-sick mandolins were playing somewhere, calling to

Maria. Maria everywhere! But my love breathed the great peace and was fanned by the purity of the moonlight, like the little white houses below. . . .

The high wall at the side of the path concealed the moon from us, and there we saw a statue of the Madonna in a niche quite high above the path and bushes. The weak flame of a little lamp glowed in front of the Queen, and in her watchful silence she seemed so lifelike that my heart went a little cold from sweet fear. Toppy lowered his head and mumbled some prayer or other, while I removed my hat and thought: 'Just as you are standing high above this bay filled with hazy moonlight and mysterious enchantment, so too *Maria* stands over my soul . . .'

Another of Andreyev's unfinished works, the story *Lost in the World*, is also set in Italy, and it provides a final example of the way Andreyev's muse sometimes worked by transforming an experience that was happy in his own life into a melancholy one in the lives of his fictitious characters:

Among the people travelling about sunny Italy you come across solitary individuals who look sad and gloomy. They are life's unfortunates, whose mental sufferings have driven them from their homes to seek distraction and salvation from death among the bewitchingly beautiful sights for which this land is so famous. . . .

One of these travellers, a Russian, was once sitting in Bologna station waiting for a train to the south. He had already stopped off in Genoa, Milan and Venice, where for whole days he had hired a gondola for solitary and silent rides up and down the canals, and now he was making for Florence; but there had been some confusion about connecting trains, he had not understood something in Italian and now he had to sit in the little Bologna buffet and wait in patient boredom for two hours. . . .

Doing everything that other tourists did, the Russian ate a portion of macaroni, which smelled of beef suet and which he was already fed up with, and drank two glasses of crimson chianti, which made him purse his lips as if it had been ink; he tried peeling an orange, but it turned out to be unbearably sour – and not having anything else to do, he sank patiently into the boredom of a long wait.

'No, I was stupid not to shoot myself straight away, rather than coming here and buying these suitcases,' the Russian thought, as he intently smelled the thick orange peel. 'After all that's how I'll have to end it all anyway. I shouldn't have bought any suitcases or adopted this idiotic costume, I look even more suicidal in it. Can anyone tell that I'll soon kill myself?'

He looked around slowly: everyone was minding their own business and was indifferent to him. And Italy lay indifferently around them, with its fog and night, its railways tracks and signal-lights, its hotels and towns. . . . And these little tables with their table-cloths were also Italy, and their arrangement was eternal: they had stood like this before his arrival, and they would stand like this later on, when . . . it did not matter when. And there were food and wine

stains on the table-cloths, on his table-cloth, too, someone had made a stain and then left, and later he would leave . . . it did not matter what happened later.

He smiled as he examined the faint bluish stain, which looked like a frog, and did not raise his head when outside the window a train roared in and stopped – it was not his train and it was not worth raising his head. And the train roared out again, while its passengers began coming into the buffet, banging the door and hurrying needlessly, as if they still carried with them a particle of swift motion. They found seats, ordered meals and chianti, and were evidently also waiting for connections. A lady in black occupied a table by the opposite wall, and a porter put her things on the floor with a thud, which drew the Russian's attention to them, although he did not raise his head fully. . . .

Frowning, he indifferently transferred his gaze to the lady, opened his eyes wide, fixed them on her – and then suddenly and in a flash something happened which always happens suddenly and in a flash, since time does not exist for it and distance is of no importance. Love? Yes, love.

73 'CAPRI. GORKY'S TERRACE'. After over three years of 'heavy silence', Andreyev renewed his correspondence with Gorky in 1911 and paid him a short visit in January 1913 (see p. 115).

74 'Venice – Grand Canal'. Andreyev spent several days in Venice in 1910 and again with Anna and Savva in 1914 before their long stay in Rome. This is the Palazzo Cavalli-Franchetti (see p. 116).

Opposite:
75 'Bastia, harbour'. Andreyev and Anna called at Bastia on Corsica in December 1910 on their way from Marseilles to Florence (see p. 115).

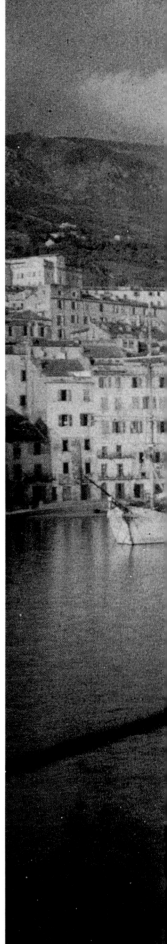

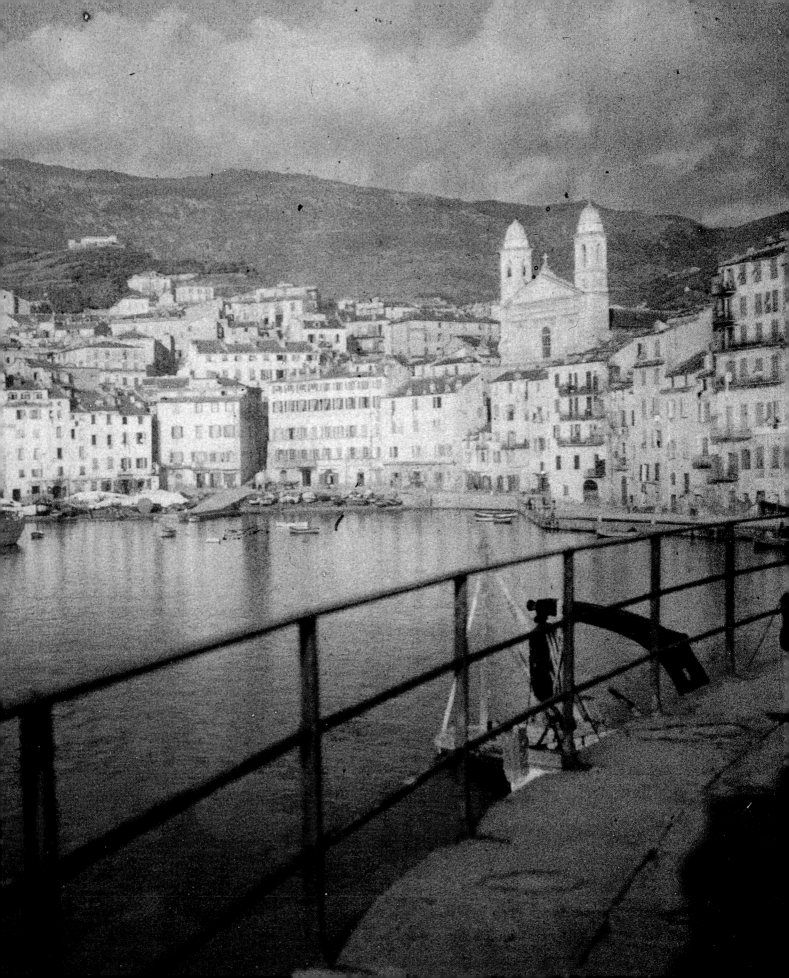

76 ANNA Andreyeva looking down on Marseilles during her and Andreyev's stay there in December 1910 (see p. 115).

77 ANNA Andreyeva in Rome in 1914 (see p. 117).

78 'PALATINO'. The ruins on the Palatine Hill, in early 1914.

79 ANNA Andreyeva in the Roman campagna, 1914 (see p. 117).

A Portfolio of Monochromes

In addition to the Autochromes, Andreyev also took a large number of photographs in black and white. Technically and aesthetically these are less remarkable than the colour photographs, but they cover a wider time-span (he began taking them in the early 1900s) and they include subjects which do not appear in colour, such as townscapes. The following pages comprise a selection of Andreyev's monochromes, supplemented by photographs from other sources to round out the biographical story.

80 SAVVA ANDREYEV on the stairs leading up to the Victor Emmanuel Monument in Rome, 1914.

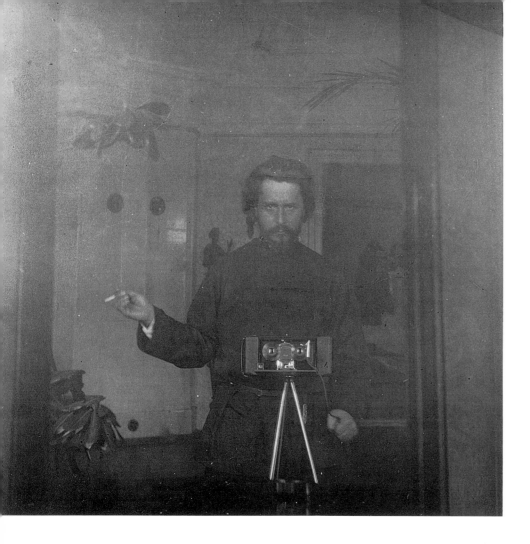

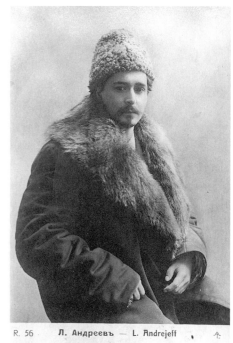

Л. Андреевъ — L. Andrejeff

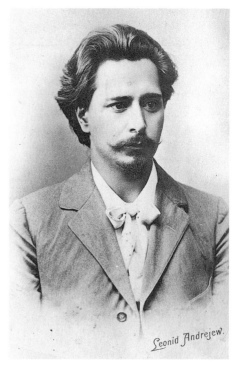

Leonid Andrejew.

PORTRAITS

Above Andreyev's self-portrait in a mirror shows the camera he used for his earliest stereoscopic photographs, c. 1903.

Above right a studio portrait of Andreyev in wolf-skin coat and Astrakhan hat sold as a postcard in the early 1900s.

Right a carte-de-visite portrait of Andreyev in his student uniform, taken in Moscow in 1894, shortly after he had transferred to Moscow University.

Far right a portrait of Andreyev taken in Moscow 1902 and sold as a postcard.

Opposite left a studio portrait of Andreyev sold as a postcard in the 1900s.

Opposite right Andreyev shaven for the summer's sailing and in his waterproofs and sou'wester, 1910s.

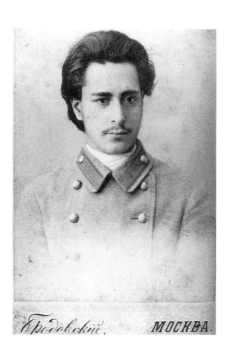

МОСКВА

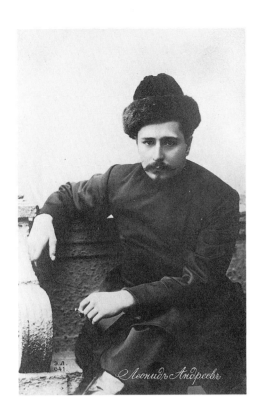

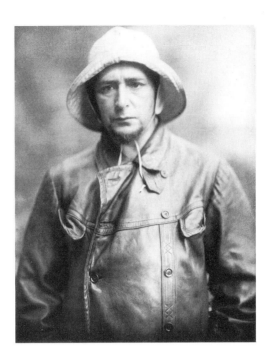

Скиталецъ М. Горькій

Л. Андреевъ Шаляпинъ Бунинъ Телешевъ Чириковъ

A group portrait of the 'Wednesday' circle, taken in the Fisher studio in Moscow in December 1902 and sold as a postcard. Standing: Skitalets (Stepan Petrov), Gorky. Seated: Andreyev, Shalyapin, Bunin, Teleshev, Chirikov.

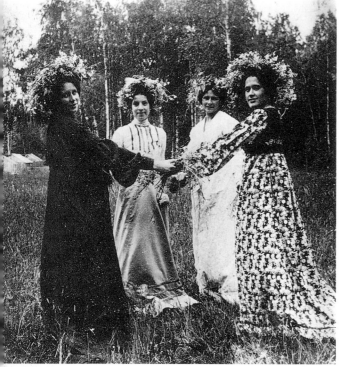
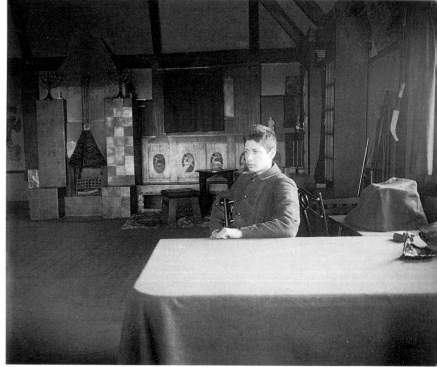

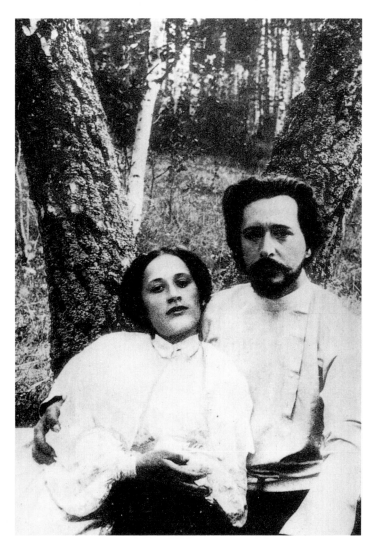

ALEKSANDRA

Far left Aleksandra Andreyeva abroad in 1905–1906.

Left Aleksandra Andreyeva.

Below far left Aleksandra Andreyeva (right) with three friends.

Below left Vadim in Andreyev's study at Vammelsuu during the First World War.

Right Andreyev and Aleksandra at Butovo near Moscow shortly after their marriage in 1902.

ANNA

Below right Andreyev standing by his portrait of Anna nursing Savva at Vammelsuu in 1909–1910.

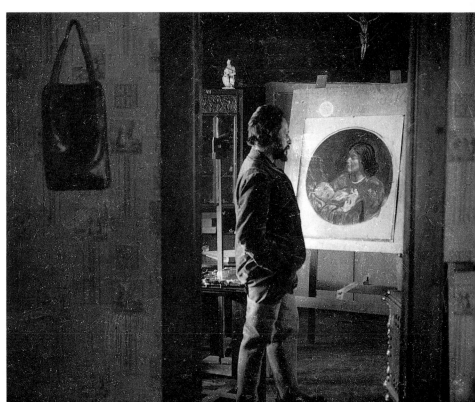

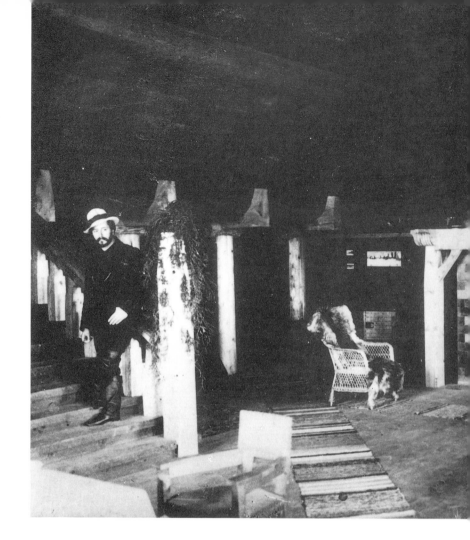

THE HOUSE ON THE GULF OF FINLAND

Right Andreyev in the entrance hall of the Vammelsuu house, 1908.

Below the house at Vammelsuu in the process of construction, 1908.

Below right the dining area of the Vammelsuu house.

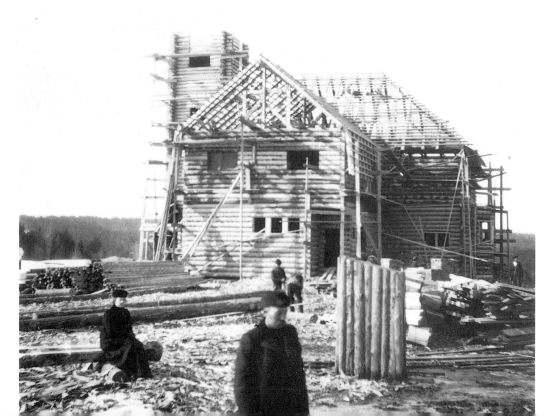

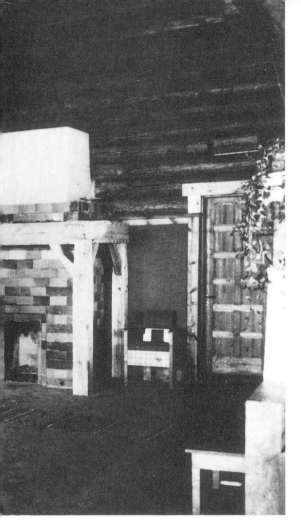

Below Andreyev at his desk in the study at Vammelsuu.

Bottom Andreyev's study at Vammelsuu, photographed by Bulla in 1912.

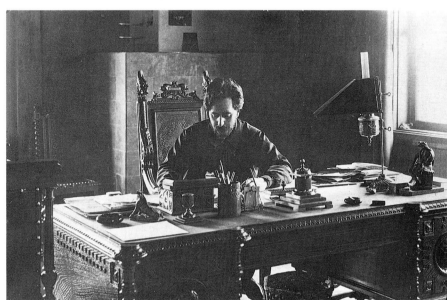

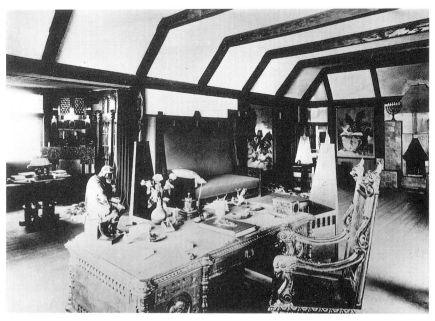

Andreyev preparing to take an outdoor photograph.

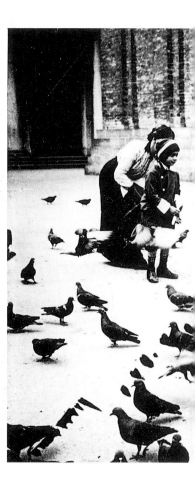

Andreyev and Savva feeding the pigeons on the Piazza San Marco, Venice, February 1914.

St Petersburg: St Isaac's Cathedral, viewed from the Neva embankment.

The Neva embankment looking towards the Winter Palace and the pontoon bridge to Vasilevsky Island.

Right views of Novgorod, which Andreyev visited with Vadim and his tutor, Mikhail Petrenko, in the summer of 1910.

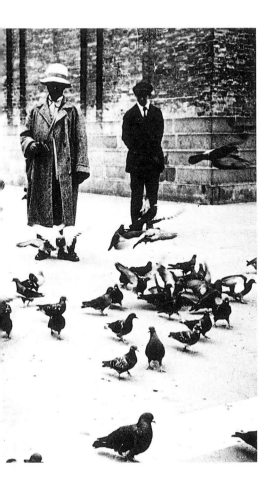

St Petersburg: The Arch of the General Staff building looking onto Palace Square.

MAN OF THE THEATRE

Left Andreyev's pastel painting of Someone in Grey, the fate figure in *The Life of Man*, which hung on the staircase of the Vammelsuu house.

Right Andreyev with his mother and brother, Andrei, staging a mock coronation in the study at Vammelsuu.

Below a still from the film of Andreyev and his family at Vammelsuu shot by Drankov in 1909. Andreyev is recording the prologue to *The Life of Man*, spoken in the play by Someone in Grey.

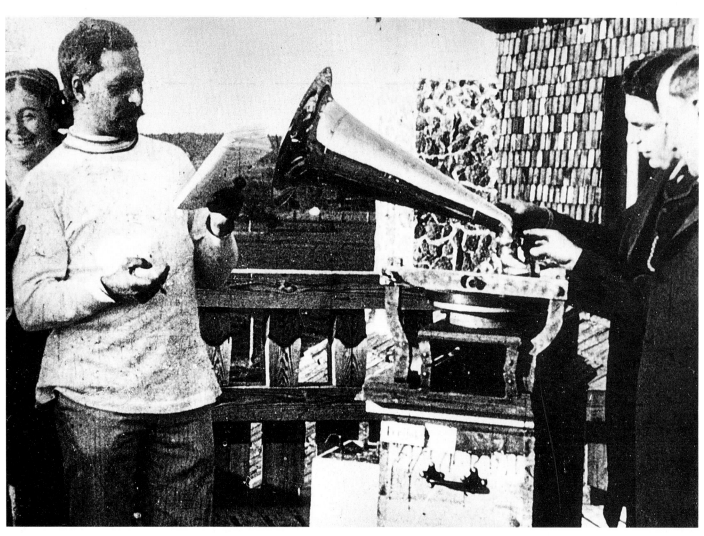

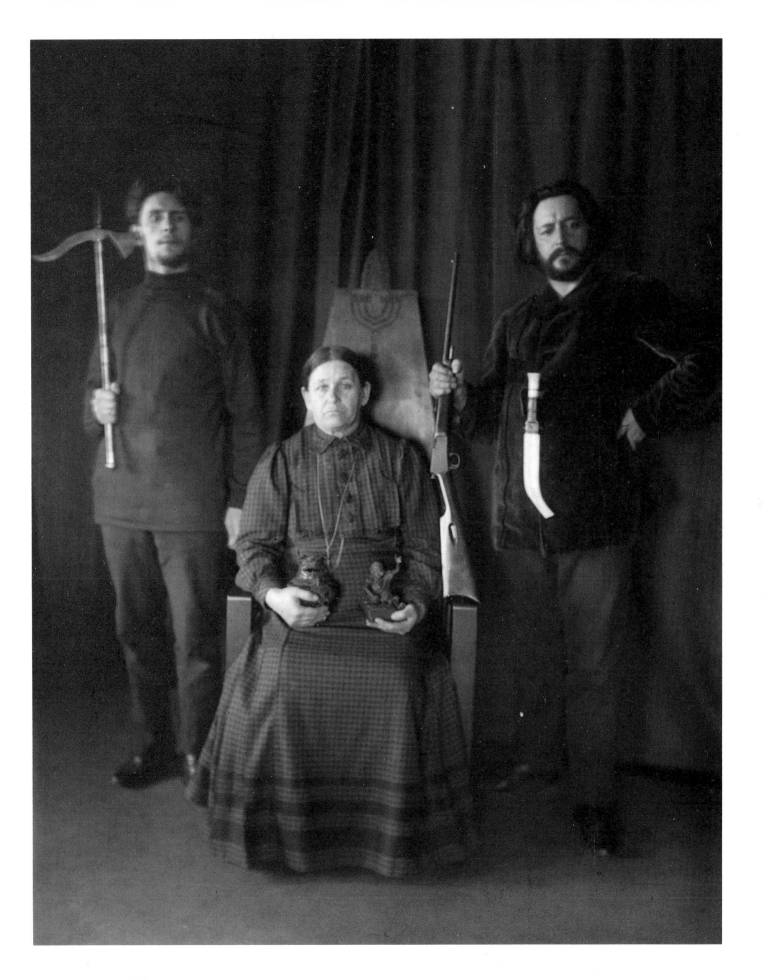

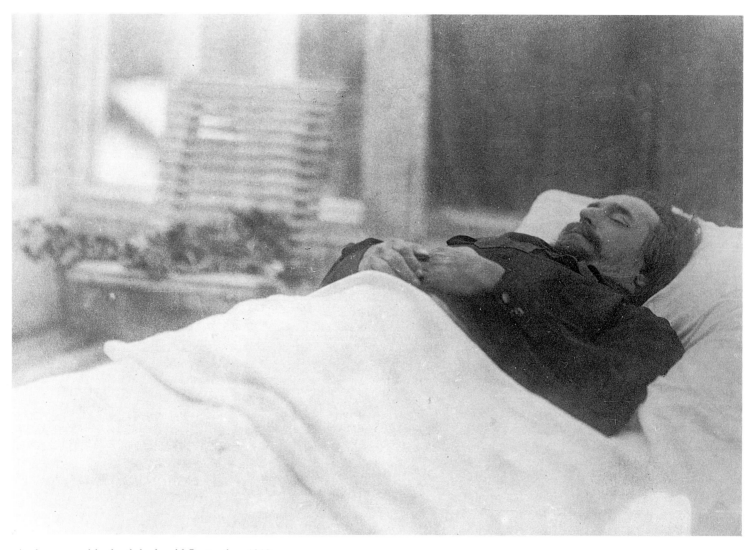

Andreyev on his death-bed, mid-September 1919.

The Lumière Autochrome Process

In the last decade of the nineteenth century experimenters and manufacturers were striving to produce a fully practical method of photography in colour, the basic theory of which had been known for thirty years. The most successful of their attempts involved covering a glass plate with finely ruled ink lines, in the three primary colours of red, blue and green, which was then used as a colour screen through which to make an exposure onto a conventional black and white plate.

This plate was then processed to form a positive, rather than a negative, image then carefully registered with the colour screen to give a transparent rendering of the original scene in colour.

The success of these processes was, to a large extent, dependent on the ability accurately to rule very fine lines, at right angles to each other, in the primary colours. Even with lines ruled as finely as one tenth of a millimetre there was a tendency to see the screen rather than details of the picture. This problem was solved in 1904 when the French brothers Auguste and Louis Lumière announced that they had developed a process which overcame the difficulties of the earlier ruled screen methods by using extremely fine particles of colour, in random formation, as their colour screen. The particles they chose were potato starch grains each measuring about a fifteen-thousandth part of a millimetre which were dyed in the red, blue and green primary colours, mixed until they appeared as a grey powder, then scattered onto a sheet of glass covered with a sticky coating.

After flattening under great pressure the screen was given a dusting of carbon black to fill any gaps between the grains. The Lumières then had an extremely fine, randomly produced colour screen on which directly to coat their black and white photographic emulsion.

This was exposed in the normal plate holder of the camera with the colour screen towards the lens. The image formed on the black and white emulsion was broken down into its component colours by the starch grains which acted as microscopic colour filters. When processed to give a positive transparent image the picture was immediately viewable in full colour, no complicated registration with a separate ruled colour screen being necessary.

When the Autochrome process became commercially available in 1907 it was an immediate success. Between the year of its introduction and 1913 the manufacture of Autochrome plates climbed to over one million plates a year and, because of the relative ease with which it could be used, the process was employed throughout the world. The purchase of Autochrome plates and a few simple chemicals meant that processing could easily be carried out in remote locations and at the convenience of the operator – factors which must have appealed to Andreyev in his excitement over photography.

Among the fine plates housed in the Leeds Russian Archive are a few examples of another process based on the ruled screen method. This is almost certainly the British Paget Screen Process and may have been used by Andreyev because of a difficulty in obtaining Autochrome plates from France during the First World War.

On its introduction the Autochrome process was relatively slow, as a yellow filter had to be used over the camera lens to compensate for the excessive blue bias of the material. Exposures of 1–2 seconds at $f.8$ in a brightly lit landscape were common but, as emulsions became more sensitive and their range extended to cover all parts of the spectrum, the process became capable of producing near instantaneous pictures.

The Lumière Autochrome process gave an impetus to popular photography in colour similar to that give by the introduction of the Kodak Box Brownie camera and roll film by George Eastman in 1888.

Ken Phillip

The publishers would like to thank Expo Plus Limited, 52 Poland Street, London W1, for so skilfully and accurately converting the original glass slides to the colour transparencies from which the colour reproductions were made.

Sources of Quotations

All extracts from Andreyev's diaries, letters and unpublished works have been translated from the original manuscripts and typescripts in the Leeds Russian Archive's Leonid Andreyev Collection.

The passage by Kornei Chukovsky (pp. 21–24) was first published in *Kniga o Leonide Andreeve: Vospominaniya M.Gor'kogo, K. Chukovskogo . . . [A Book about Leonid Andreyev: The Memoirs of M.Gorky, K. Chukovsky . . .]* (St Petersburg & Berlin, 1922), pp. 41–52.

The letter to Aleksandra quoted on p. 20 was published in Vadim Andreyev: *Detstvo [Childhood]* (Moscow, 1963), p. 156–8. The other extracts by Vadim on p. 51 and p. 83 are from the same book, p. 46–8 and p. 137 respectively.

The article by Herman Bernstein (p. 53–4), 'With the Author of "Red Laughter": Interview with Leonid Andreyev, Russia's Most Popular Writer To-day – A Modern of the Moderns', is quoted from the New York Times, 5 September 1908, p. 487.

Vera Beklemisheva's account of the house (p. 54–6) is from *Rekviem: Sbornik pamyati Leonida Andreeva [Requiem: A Miscellany in Memory of Leonid Andreyev]*, edited by D.L. Andreyev and V.E. Beklemisheva (Moscow, 1930), pp. 198–202.

Andreyev's letter to Lvov-Rogachevsky (p. 82) appears in V. L'vov-Rogachevskii, *Dve pravdy: Kniga o Leonide Andreeve [Two Truths: A Book about Leonid Andreyev]* (St Petersburg, 1914), pp. 20–21.

The newspaper interview on p. 87 appeared in Utro Rossii, 8 September 1913 – quoted in V. L'vov-Rogachevskii, op cit, p. 22.

The extract at the end of Section III (p. 88) was first published with the title 'Shkhery' ['The Skerries'], in *Andreevskii sbornik: Issledovaniya i materialy [An Andreyev Miscellany: Studies and Publications]*, edited by L. N. Afonin (Kursk, 1975), pp. 201–204.

Bibliography

Selected Translations

Great Russian Short Stories, edited by Stephen Graham (New York: Liveright, 1975; London: Benn, 1959)

Great Russian Stories, edited by Isai Kamen (New York: Random House and Vintage Books, 1959)

He Who Gets Slapped, translated by Gregory Zilboorg (Westport, Ct: Greenwood Press, 1975)

King Hunger, translated by Eugene Kayden (Sewanee, Tennessee: University of the South University Press, 1973)

Letters of Gorky and Andreyev, 1899–1912, translated by Lydia Weston, edited by P. Yershov (New York: Columbia University Press; London: Routledge and Kegan Paul, 1958)

Masterpieces of Russian Drama, edited by George Noyes (New York: Dover Books, 1960)

Russian Short Stories, translated by Rochelle Townsend (London: Dent, 1961; New York: Dutton, 1961)

The Seven That Were Hanged and Other Stories (New York: Random House, 1958; 1962)

The Shield, edited by M. Gorky, L. Andreyev and F. Sologub, translated by A. Yarmolinsky (Westport, Ct: Greenwood Press, 1975)

Twentieth-Century Russian Plays: An Anthology, edited by Franklin Reeve (New York: Norton, 1973)

Visions: Stories and Photographs, edited by Olga Andreyev Carlisle (San Diego, New York, London: Harcourt Brace Jovanovich, 1987)

When the King Loses His Head and Other Stories, translated by Archibald Wolfe (Freeport, NY: Books for Libraries Press, 1970)

Selected Criticism

Emma Goldman, *The Social Significance of the Modern Drama* (Boston: Badger, 1914)

Alexander Kaun, *Leonid Andreyev: A Critical Study* (New York: Huebsch, 1924; Blom, 1969; AMS Press, 1970)

H.H. King, *Dostoevsky and Andreyev: Gazers Upon the Abyss* (New York, 1936)

Vasa Mihailovich, *Modern Slavic Literatures: A Library of Literary Criticism*, volume 1 (New York: Ungar, 1972)

Mihajlo Mihajlov, *Russian Themes* (London: Macdonald, 1968)

Josephine Newcombe, *Leonid Andreyev* (Letchworth: Bradda, 1972; New York: Ungar, 1973)

Colin Wilson, *The Strength to Dream: Literature and Imagination* (Boston: Houghton Mifflin, 1962)

James Woodward, *Leonid Andreyev: A Study* (Oxford: Clarendon Press, 1969)

Index

Numbers in bold refer to colour photographs